IMAGES
of America

BAYSTATE
MEDICAL CENTER

ON THE COVER: The Merrick Operating Room, built in 1896, was located in the surgical pavilion of Springfield Hospital. Funds for this building were bequeathed in 1887 by William Merrick, treasurer of the Springfield Gas Light Company, who died at a young age without heirs. Physicians and student nurses are seated at right, observing as three surgeons, a nurse anesthetist, a circulating nurse, and a scrub nurse conduct an abdominal operation. (Courtesy of Baystate Health Marketing & Communications.)

IMAGES
of America

BAYSTATE
MEDICAL CENTER

Thomas L. Higgins, MD,
and Linda S. Baillargeon

ARCADIA
PUBLISHING

Copyright © 2014 by Thomas L. Higgins, MD, and Linda S. Baillargeon
ISBN 978-1-4671-2253-5

Published by Arcadia Publishing
Charleston, South Carolina

Printed in the United States of America

Library of Congress Control Number: 2014938128

For all general information, please contact Arcadia Publishing:
Telephone 843-853-2070
Fax 843-853-0044
E-mail sales@arcadiapublishing.com
For customer service and orders:
Toll-Free 1-888-313-2665

Visit us on the Internet at www.arcadiapublishing.com

To the physicians, nurses, and all team members who have, in tireless dedication to patients and families, kept the restorative light of Baystate Medical Center aglow for 144 years. May this compendium of history honor Michael J. Daly, who served from 1980 to 2004, and outgoing leader of 22 years Mark R. Tolosky and inspire new leader Mark A. Keroack, MD.

CONTENTS

Acknowledgments 6

Introduction 7

1. Springfield Hospital in the 19th Century 9

2. The Hampden Homeopathic and Wesson
 Memorial Hospitals 23

3. Wesson Maternity Hospital 33

4. Springfield Hospital in the Early 20th Century 45

5. Springfield Hospital School of Nursing 59

6. The Postwar Years 75

7. From Hospital to Medical Center 93

8. Medical Center of Western Massachusetts/
 Baystate Medical Center 105

9. Baystate in the 21st Century 123

ACKNOWLEDGMENTS

We would like to thank Baystate Medical Center and the many people and departments who contributed to this project. We are especially indebted to Ellen Brassil and Sandy Savenko at the Baystate Medical Center Health Sciences Library and Maggie Humberston at the Lyman & Merrie Wood Museum of Springfield History. Photograph captions were augmented with reference to previously published sources, particularly William A.R. Chapin's *Wanted: Tall Men* and *A Rich Heritage: One Hundred Years of Nursing at Baystate Medical Center* by Jeanne S. Murphy, RN, MS. Other important sources included annual reports of Baystate Medical Center and its predecessor organizations, brochures from the school of nursing, and "The Problem with Planning: Springfield Hospital and the Development of the U.S. Healthcare System, 1890–1980," a PhD dissertation presented by Bruce Saxon at the University of Massachusetts Amherst in 1996. We would like to thank the many past and present Baystate employees who shared their recollections, especially Martin Broder, Richard Brown, Mary Brunton, Robert Ficalora, Burritt Haag, Alvin and Mary Phaneuf Keroack, John Landis, Patricia Miller, Eckart Sachsse, Jeffrey Scavron, Bev Siano, Mark Tolosky, and Linda Yelinek.

Unless otherwise noted, images in this volume were drawn from the archives of Springfield Hospital and Baystate Medical Center, now housed at the Lyman & Merrie Wood Museum of Springfield History in Springfield, Massachusetts; those provided by Baystate Health Marketing & Communications are designated as BHM&C. Jodi Olmsted and Todd Lajoie were instrumental in photographing and scanning images and artwork displayed on campus. Suzanne Higgins and Patricia McArdle provided critical reading of the text. Special thanks go to Judith Vadnais and Meggan Evans, who patiently transcribed the captions, and Suzanne Hendery, vice president of marketing and communications, who facilitated this project. All proceeds from the sale of this book will be donated to the Internal Medicine Residency Education & Research Fund.

Introduction

Springfield, Massachusetts, sits on the Connecticut River, just a few miles north of the Connecticut border. It was established in 1636, initially as part of the Connecticut Colony. Thanks to its location at the confluence of the Connecticut, Westfield, and Chicopee Rivers, it became an early agricultural and trading center. It is now known as the "City of Homes" and as the birthplace of basketball, but perhaps the most important contributor to its growth and development was its selection in 1777 as the site of the first US National Armory. Prior to the American Revolution, most manufactured goods were imported from Britain. Realizing the vulnerability of the colonies, George Washington and Henry Knox saw to the establishment of the National Armory in Springfield. The location was chosen in part because Springfield was sufficiently far inland and upriver from the falls on the Connecticut River, near present-day Windsor Locks. In 1794, the first American musket was produced, followed by the famous Springfield rifle. From 1794 until its closure during the Vietnam War, the Springfield Armory served as a magnet for skilled laborers, allowing Springfield to become a center of precision manufacturing. The availability of a skilled workforce subsequently contributed to many firsts: interchangeable parts and the assembly line for manufacturing, the American horseless carriage, vulcanized rubber, and the Duryea brothers' gasoline-powered car. Springfield's location on the major east-west route between Boston and Albany and on the north-south route between New Haven and Vermont also made it a transportation hub and a logical junction for the first US railways. Precision manufacturing of guns and profits from the railroads helped establish the predecessor hospitals to Baystate Medical Center.

Today's hospitals feature more cutting-edge technology, but they are otherwise bigger and better versions of what existed in our parents' or grandparents' time. From the start of the 20th century, hospitals have featured inpatient wards and private rooms, radiology and laboratory facilities, and operating rooms, along with staff comprising student nurses, interns, and often, resident physicians. Yet hospitals today would be almost unrecognizable to a time traveler from 200 years ago. Most health care in the 19th century was delivered at home, with hospitals viewed as a last resort for those without the resources or family to see them through illness. Though a small number of American institutions began to adopt the European model that had developed from care provided in monasteries, it was not until the 1880s that hospitals became available to most physicians and patients in the United States. Physicians trained by apprenticing, with only minimal requirements for formal medical school instruction. Graduate medical education in the form of internships was limited to selected graduates of medical schools affiliated with a hospital. In 1873, the American Medical Association estimated that only 178 acute care hospitals existed in the United States, versus over 5,000 today. Baystate Medical Center traces its roots to Springfield City Hospital, which, opened in 1870, predates such august institutions as Johns Hopkins Hospital (1889); St. Mary's Hospital (1889), affiliated with the Mayo Clinic in Rochester, Minnesota; and the Cleveland Clinic (1921).

Medical care in the early 1800s did not differ remarkably from that provided in antiquity, but the scientific discoveries of the 19th century would soon translate to improved possibilities. One

event that led to the rise of the modern hospital was the first public demonstration of diethyl ether as a general anesthetic at the Massachusetts General Hospital in 1846. Anesthesia made it possible to conduct longer and more complex operations, including those that involved opening the abdomen. Acknowledgment of the need for antisepsis mandated purpose-built operating rooms, replacing bedside procedures or the kitchen table. The massive increase in the number of hospitals from the late 1880s through the 1920s coalesced around the need for surgical operating rooms and inpatient beds for convalescence. A common story emerges in the last two decades of the 19th century, when a local industrialist (or his widow) recognized the need to establish a hospital in the community. In western Massachusetts, early donors included Chester and Dorcas Chapin, who contributed railroad money to build Springfield Hospital in 1886, and Daniel and Cynthia Wesson, who provided funds from gun manufacture to support both Hampden Homeopathic and Wesson Maternity Hospitals in 1900 and 1906, respectively.

In this pictorial history, we will trace the people, buildings, and events that form the basis of Baystate Medical Center today.

One

SPRINGFIELD HOSPITAL
IN THE 19TH CENTURY

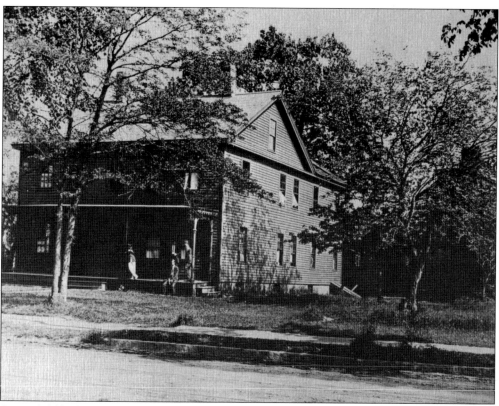

Springfield had been well established as the location of the National Armory by the 1860s. Many sick and wounded soldiers were brought to Springfield during and after the Civil War, and in 1868, Dr. George S. Stebbins, the city physician, recommended the establishment of a city hospital. The City of Springfield purchased and remodeled a farmhouse on Boston Road to serve as a hospital in 1869, and the Springfield City Hospital opened in 1870, remaining at this site until 1889.

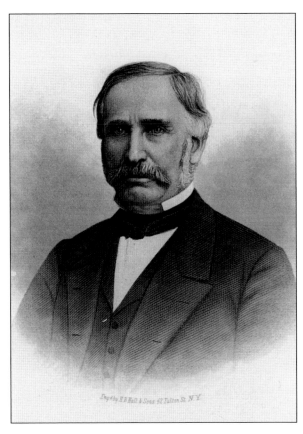

Chester William Chapin (1798–1883) was a descendant of Deacon Samuel Chapin, pilgrim immigrant and prominent early settler of Springfield, Massachusetts. Chester Chapin invested in stagecoach lines between Hartford, Connecticut, and Brattleboro, Vermont. When steamboats first began to service the Connecticut River between Hartford and Springfield, he bought those, later expanding service to New Haven, Connecticut, and New York City. Chapin was a founder of the Western Railroad, a predecessor of the Boston & Albany Railroad, which eventually became part of the New York Central Railroad. He also was a founder of the Connecticut River Railroad, ultimately part of the Boston & Maine Railroad system. Chapin served as a Democrat in the 44th Congress (1875–1877) and died in 1883. His widow, Dorcas Chapin, died in 1886 and bequeathed $25,000 on condition that a like sum be raised by subscription to support Springfield Hospital.

This plat from 1870 shows the location of the Horacio A. Fuller farm, site of today's Baystate Medical Center. Landowners in the vicinity included city physician Dr. George Stebbins, members of the Chapin family, and Dr. Josiah Gilbert Holland, a physician and prominent American novelist and poet. (Author's collection.)

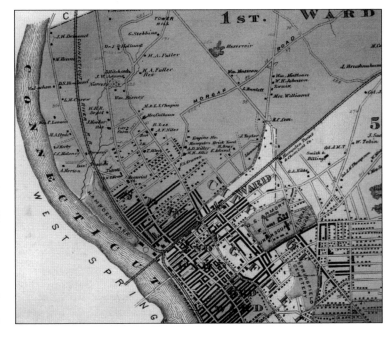

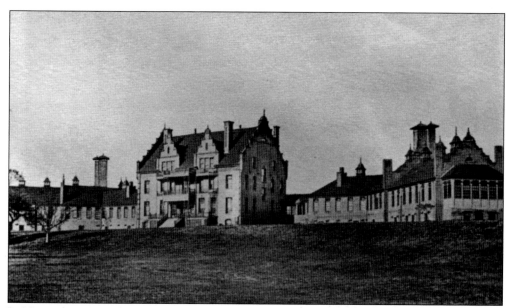

In November 1887, the trustees of Springfield Hospital purchased 35 acres of land on North Chestnut Street and constructed a new hospital building with 50 beds. The facility, located on a knoll above a spacious front lawn, was dedicated on May 14, 1889.

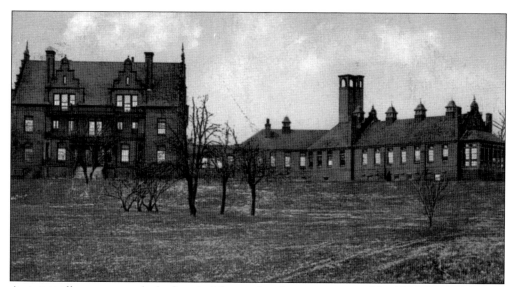

As originally constructed, the hospital featured a three-story central building flanked by two one-story pavilions. The central building contained administrative offices and private rooms and housed student nurses on the top floor. Male and female wards occupied the flanking pavilions. Beginning in 1894, second stories were added to both pavilion wings to increase capacity to 100 beds. (Author's collection.)

Springfield Hospital is shown shortly after its 1889 opening. The flanking wings with open wards are now long gone, but the tall central building survives, surrounded by the 1931 Springfield Building in the front, passageways on either side, and the 1986 Daly Building to the rear. The sign reads, "Springfield Hospital. Visiting Days: Sundays, Wednesdays, and Fridays 2 P.M. to 4 P.M." (Author's collection.)

Stephen W. Bowles, MD, (1836–1895) was a visiting physician from the inception of the hospital in 1889 until 1895, and he served as president of the medical staff from 1889 to 1893.

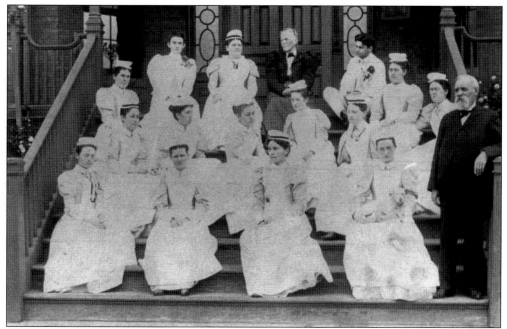

Lucinda Howard, a trustee of Springfield Hospital from 1883 to 1899, convinced the board to establish a training school for nurses. The school opened in 1892, and by 1893, a total of 22 probationers had entered the two-year training program. This photograph was taken on the front steps of the main building.

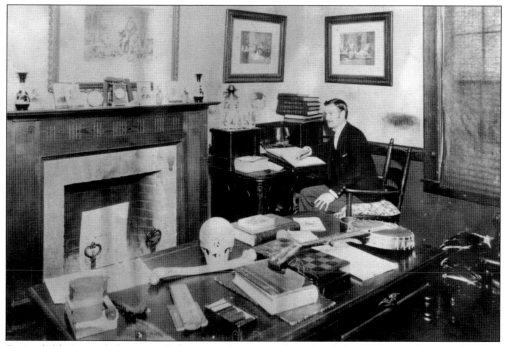

Springfield Hospital also trained physicians from its earliest days. This 1892 view shows Dr. Walker B. Rossman in the interns' office. In addition to the expected books and skeleton, a chessboard and banjo are visible, offering clues as to how interns might have spent their free time.

Elizabeth Moore was a member of the first graduating class of the Springfield Nursing School in 1894. She is shown holding the first baby born at Springfield Hospital, who patient logs confirm was the only infant delivered at the facility that year. Most deliveries occurred at home, with only St. Luke's Maternity Hospital on Oak Street in downtown Springfield providing inpatient maternity care at that time.

The hospital's annual report enumerated diseases and injuries encountered at Springfield Hospital in the fiscal year of 1894. Of the 143 patients seen that year, 19 died in the hospital, creating a mortality rate of 13.3 percent. Today's insurance carriers would likely deny inpatient reimbursement for general debility, eczema, hysteria, or general malaise, all of which were noted as admission diagnoses in 1894.

TABLE SHOWING DISEASES AND INJURIES, WITH THE RESULTS, FROM DECEMBER 1, 1893, TO DECEMBER 1, 1894.

DISEASES AND INJURIES.	MALES.	FEMALES.	CURED.	IMPROVED.	NOT IMPROVED.	REMOVED OR NOT TREATED.	DIED.	REMAINING IN HOSPITAL DEC. 1, 1894.	TOTAL.
MEDICAL.									
Abortion,		1	1						1
Alcoholism,	4	1	3	1			1		5
Anæmia,		1				1			1
Angina pectoris,	1	1			1				1
Apoplexy,	1							1	1
Appendicitis,	1		1						1
Bronchitis,	1	2	3						3
Cancer, stomach,	1					1			1
Colic, renal,	2		2						2
Constipation,	1	1	2						2
Debility, general,	1	1	2						2
Diarrhœa, senile exhaustion,	1						1		1
Dyspepsia, intestinal,	1	1	1						2
Enteritis,	1	1	2						2
Eczema,	1	1	1					1	2
Gastric catarrh,	2	4	5	1					6
" ulcer,		1					1		1
Gonorrhœa,	1		1						1
Heart, mitral regurgitation,	3	2		4			1		5
" endocarditis,		1					1		1
Hysteria,		1			1				1
Labor,		1							1
La Grippe,	1	6	7						7
Locomotor ataxia,	1						1		1
Liver, congestion,	1	1	1	1					2
Leucorrhœa,		1		1					1
Malaria,	1	2	1	2					3
Malaise, general,	2	1	2	1					3
Melancholia,	1					1			1
Nephritis, acute,	1				1				1
" chronic interstitial,	2				1	1			2
Neurasthenia,	1	4	2	3					5
Neuritis,		1	1						1
" multiple,		1					1		1
Pelvic cellulitis,		2						2	2
Peritonitis,		1	1						1
Phthisis,	3	1		2			2		4
Pleuritis,	4	4	6				2		8
Pneumonitis,	7	2	5				3	1	9
Poisoning, laudanum,	1						1		1
Renal calculi,	1		1						1
Retroversion uterus,		1		1					1
Rheumatism, acute articular,	7	2	3	6					9
Sciatica,	1	1		2					2
Sunstroke,	3		3						3
Tonsilitis, follicular,		1	1						1
Typhoid fever,	15	16	21				4	6	31
Total,	73	70	80	29	2	2	19	11	143

William Merrick was born in 1849 and died suddenly at age 37 in 1887. He was an 1870 Harvard classmate of Springfield physician F.W. Chapin. William's father, Solyman Merrick, patented the first adjustable wrench in 1835. Solyman was also a principal founder and owner of the Springfield Gas Light Company, where William was elected as treasurer just before his death. Unmarried, William left a bequest of over $98,000 to the hospital corporation to provide for maintenance of the hospital and the erection of a surgical building. A plaque honoring this bequest graces the first floor of today's Springfield Building. The surgical pavilion was established in 1896, separating patients with open wounds from those with infectious diseases.

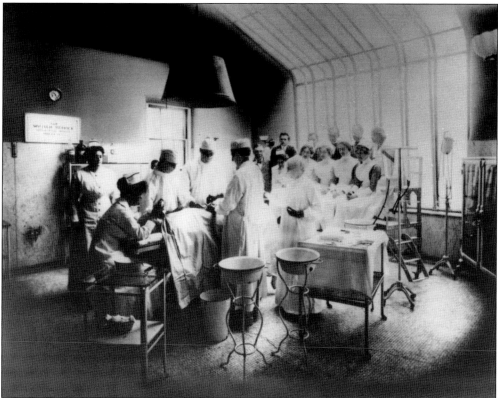

The Merrick Operating Room had extra-large windows to maximize available sunlight in a time when electrical lighting was primitive. The large windows would have faced north to take advantage of natural light while minimizing the solar heating encountered with south-facing windows. The operating room also featured an observation area for nursing students.

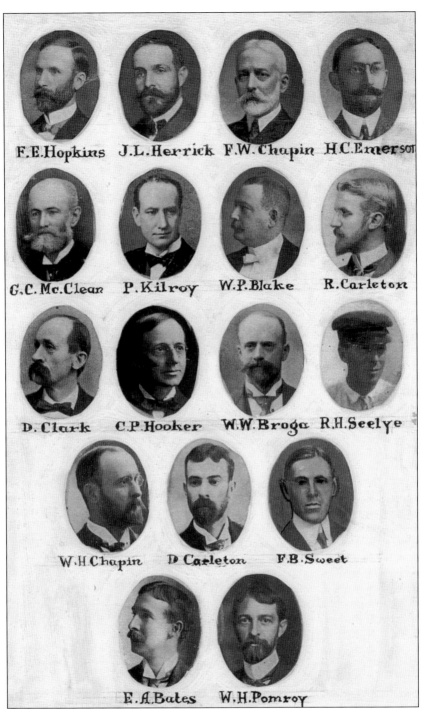

F.E.Hopkins J.L.Herrick F.W.Chapin H.C.Emerson

G.C.McClean P.Kilroy W.P.Blake R.Carleton

D.Clark C.P.Hooker W.W.Broga R.H.Seelye

W.H.Chapin D Carleton F.B.Sweet

E.A.Bates W.H.Pomroy

Springfield doctors are featured in this composite from 1903. Of note are Frederick E. Hopkins, MD, who was an ear, nose, and throat surgeon, and Dr. Ralph H. Seelye (1865–1955), who attended Amherst College (where his uncle was president) before training at the Massachusetts General Hospital. His father, L. Clarke Seelye, was the first president of Smith College and married to Henrietta Chapin Seelye.

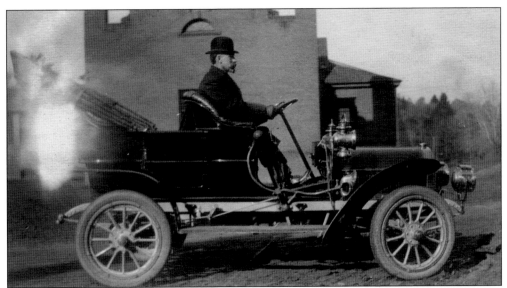

Dr. Frederick Hopkins is pictured driving a new Stevens-Duryea in 1905. Stevens-Duryea automobiles were manufactured in Chicopee Falls, Massachusetts, in the early 1900s. Unfortunately, after the company had aggressively expanded to a larger plant in East Springfield, financial difficulties forced a halt to production in 1915. The plant later became the site of the New England Westinghouse Company.

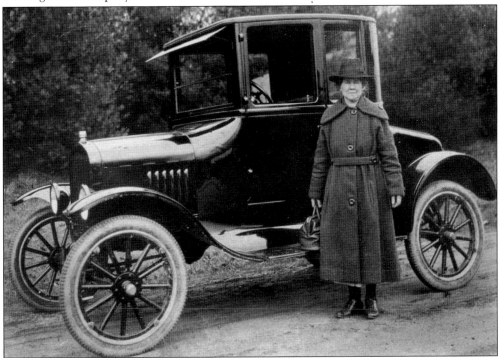

The history of visiting nurses dates back to the 1880s, when district or visiting nurses would care for the sick poor in their own homes. This 1922 photograph shows Miss Carroll, a Ware visiting nurse, standing in front of her Ford. The Ware Visiting Nurse Association established Baystate Mary Lane Hospital in 1909.

George Dwight Pratt (1864–1947) had a distinguished career in public service. He was a fifth-generation resident of Springfield in a family descended from John Pratt, who had emigrated from England to Cambridge, Massachusetts, in 1633. Pratt served on the board of directors for the following: Third National Bank of Springfield, the Holyoke Water Power Company, and the New York, New Haven & Hartford Railroad Company. For 10 years, he also served as president of the board of trustees for Springfield Hospital as it grew from serving 400 patients per year to nearly 3,000. During Pratt's administration of the hospital, he contributed $5,000 in memory of his mother, Lucinda Orne Howard, a previous hospital trustee who had been instrumental in establishing the Springfield Hospital Training School for Nurses. The Pratt Building became the first separate location for the nursing school. Pratt also developed the plan for a memorial to Dr. Frederick Wilcox Chapin, Springfield's leading physician at the time, and personally raised $75,000 for the project.

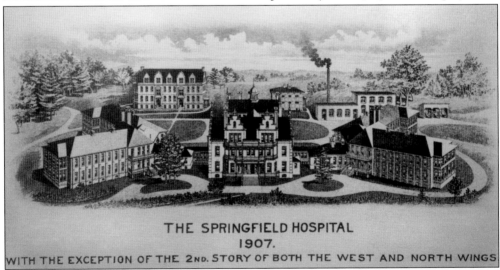

THE SPRINGFIELD HOSPITAL
1907.
WITH THE EXCEPTION OF THE 2ND. STORY OF BOTH THE WEST AND NORTH WINGS

This bird's-eye view from 1907 shows the main hospital surrounded by four wings, with the surgical pavilion connected in the rear. The Pratt Building is a short walk across the lawn behind the hospital. In the 100-plus years since this drawing, the hospital's landscape has changed considerably. The former Pratt Building site lies within the footprint of the 2012 Hospital of the Future complex, while the original 1889 hospital is situated between the Springfield and Daly Buildings. A newer facility replaced the powerhouse (rear right with smokestack) in the 1930s. (Courtesy of Baystate Medical Center permanent collection.)

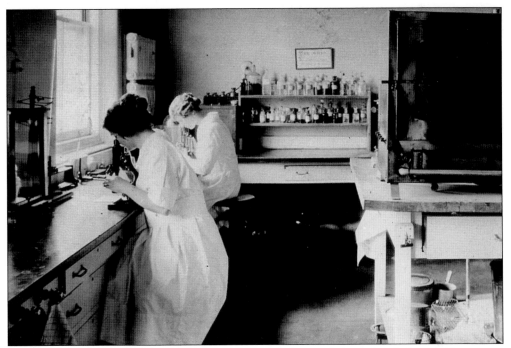

Today, laboratory medicine consists of anatomic pathology and clinical pathology, with separate divisions for clinical microbiology, clinical chemistry, hematology, genetics, and reproductive biology. In 1910, the pathological laboratory fit within the confines of this single room, where technicians are pictured examining slides under microscopes.

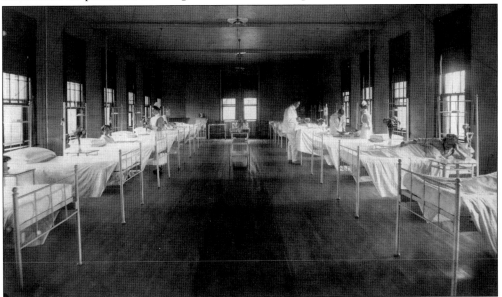

While the center section of the hospital had private rooms, most patients were cared for in one of the gender-specific wards occupying the flanking pavilions. This first-floor ward was reserved for women. With recurring epidemics of malaria, tuberculosis, typhoid, and influenza, infectious diseases were common reasons for medical admissions. While the hospital's capacity was 100 beds, the typical census hovered around 70 patients in the 1890s.

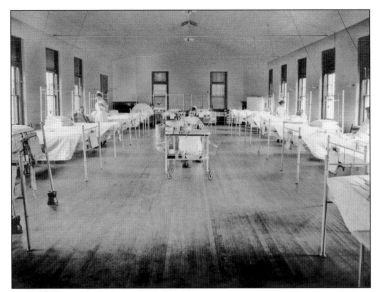

In this 1922 image, head nurse Agnes Campbell supervises activity in the male ward. The total number of hospital beds increased from 60 to 100 after 1904. (Courtesy of Baystate Archives/Springfield Museums; gifted by the daughters of Agnes L. Campbell Murdock.)

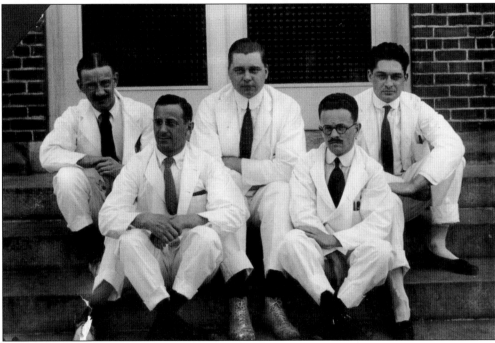

The American Medical Association began granting formal approval of hospital training programs in 1914, when Springfield Hospital was accepted, although intern training dated back to at least 1892. This undated photograph shows, from left to right, house physicians Whitcomb, Wright, Chapin, Rodding, and Feigl on the steps of the Chapin Memorial Building, constructed in 1915. By 1932, the Springfield Hospital internship included rotations at the City Home, Shriner's Children's Hospital, and the Health Department Hospital. There are numerous Springfield physicians named Chapin, beginning with Edward Chapin in the 1700s, then Charles Chapin in the early 1800s, and the previously mentioned F.W. Chapin and W.H. Chapin. Lawrence Chapin, an intern in 1915, was the son of F.W. Chapin, for whom the Chapin Building (now Wing) is named. (Courtesy of BHM&C.)

By 1912, surgical cases had increased substantially, overtaking medical admissions by a three-to-one ratio. In 1915, the Frederick Wilcox Chapin Memorial Building was opened, the first modern wing and the oldest surviving clinical area on the present-day campus. A sum of about $350,000 was raised by popular subscription, with George Dwight Pratt, then chairman of the board of trustees, heading the committee. This 1917 postcard shows its location relative to the original hospital. The building was intended to be the first of seven in a comprehensive plan first proposed in 1910, but mounting debt precluded immediate expansion. (Author's collection.)

This view of the Chapin Memorial Building was taken from about where the Springfield Building lobby exists today. The enclosed porch was removed when this freestanding structure was incorporated into the Springfield Building in 1931. Note the large operating room windows on the fourth floor. In typical fashion, these windows faced north to capture light without overheating the room. Today, this edifice houses "day stay" (outpatient procedures) on the first floor, procedure rooms on the second floor, the Katz Oncology Unit on the third floor, and echocardiography labs on the abbreviated fourth floor. (Courtesy of BHM&C.)

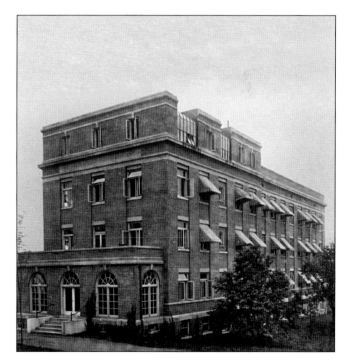

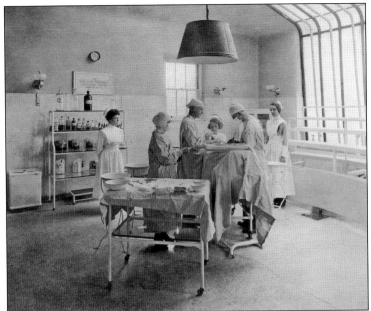

Drs. Kilburn and Carleton operate in this 1922 view of the Merrick Operating Room. By 1915, additional operating rooms had opened in the Chapin Memorial Building, but the original surgical pavilion remained in use until after the Springfield Building was opened in 1932. (Courtesy of Baystate Archives/Springfield Museums; gifted by the daughters of Agnes L. Campbell Murdock.)

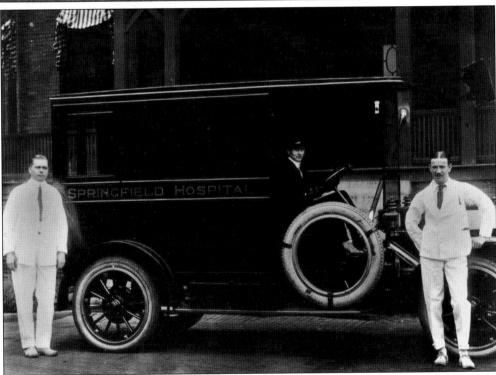

Springfield Hospital fielded its own ambulance by 1916. Although it was a private institution, there was no separate public acute care hospital for the area's indigent, as was typical in many large cities. This situation would eventually cause problems with overcrowding and maintaining the hospital's financial stability. The influenza epidemic of 1918 was particularly stressful, with a census of 197 patients during its peak. By the 1920s, overflow patients had to be accommodated in nearby houses, and planning for expanded capacity accelerated.

Two

THE HAMPDEN HOMEOPATHIC AND WESSON MEMORIAL HOSPITALS

Daniel Baird Wesson (1825–1906) cofounded the Smith & Wesson Company with Horace Smith. Wesson is pictured with two of his sons, Walter (born 1850) and Joseph (born 1859), at the company's plant in 1890. Smith & Wesson developed the first fully self-contained cartridge revolver, from which it built a lucrative business. Wesson favored homeopathic medicine, and around 1895, he offered Springfield Hospital $50,000 for their building program, with the condition that they open the hospital to homeopathic physicians. His offer was declined. Wesson's personal physician, J.H. Carmichael, was instrumental in convincing the Wessons to then create a hospital where homeopaths could practice.

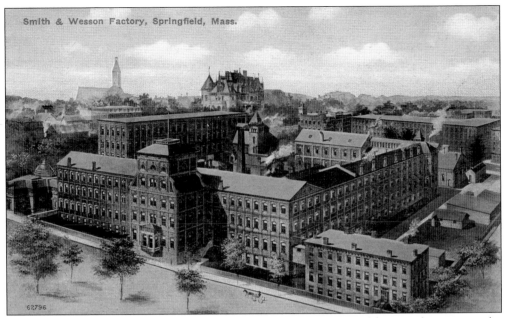

Smith & Wesson Factory, Springfield, Mass.

62796

This postcard shows the original Smith & Wesson factory in 1908. Parts of this complex survive today as the Stockbridge Court apartments. Smith & Wesson was the epicenter of arms manufacturing in western Massachusetts and Connecticut, along with the nearby firms of the Savage Arms Company of Westfield (1894), Colt Manufacturing in Hartford (1847), and other local companies supporting the industry by production and distribution of machine tools, ammunition, and manufacturing supplies. The Wesson family controlled the company until 1964.

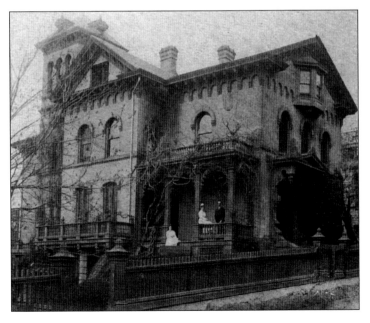

On January 29, 1900, Daniel B. and Cynthia M. Wesson donated their elegant residence at 132 High Street to serve as a homeopathic hospital. In less than six months, the home was remodeled into a 30-bed facility with 18 patient rooms and an operating theater. The Hampden Homeopathic Hospital opened on June 22, 1900, with Dr. Carmichael as chief surgeon and hospital superintendent. (Author's collection.)

The Wessons were in a position to donate their High Street residence in 1900 since they had recently moved to a more elegant home at 50 Maple Street in Springfield. Construction of this French chateau–style building began in 1892 and was completed in 1898. After the death of Cynthia Wesson on July 18, 1906, the residence remained vacant for several years. Later, the Colony Club, formed in 1915, took over the home until it was destroyed by fire on February 19, 1966. The club then occupied 110 Maple Street for several years before moving to its present location in Tower Square in 1973. (Author's collection.)

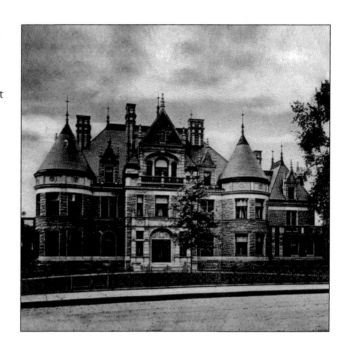

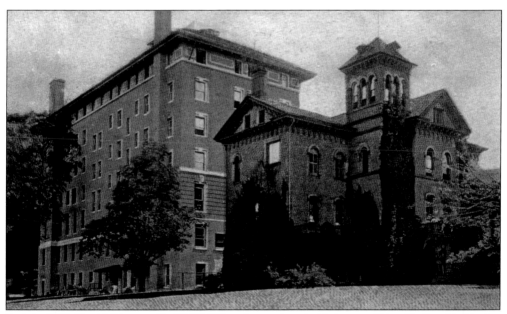

Early in 1906, Daniel Wesson gifted $435,000 to the new hospital in honor of his wife, Cynthia Marian Hawes Wesson. On April 16, Hampden Homeopathic Hospital was renamed Wesson Memorial Hospital. Wesson himself died on August 4, 1906, providing the institution with an additional $250,000 in his will. A new 100-bed building was constructed at 140 High Street, adjacent to the original hospital. With a capacity of 103 beds, the new hospital largely consisted of private rooms, as well as a few small six-bed wards. This view is looking northeast from Myrtle Street.

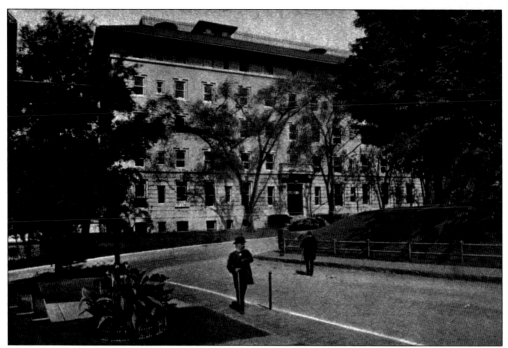

Wesson Memorial Hospital was built solidly, with windowsills made of Tennessee marble and woodwork of quartered oak. This postcard view from Ingraham Terrace shows Wesson Memorial in the early 1900s. The park bordered by High Street, Ingraham Terrace, and Union Street is now a parking lot. (Author's collection.)

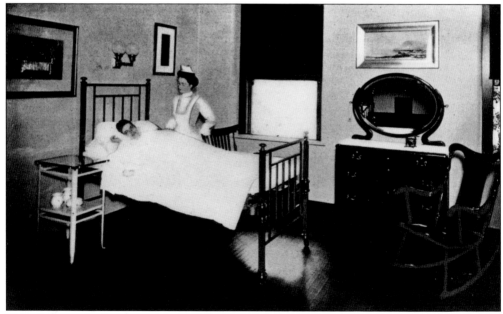

This photograph of a private room at Wesson Memorial Hospital dates from 1908. Unlike many hospitals in that era, Wesson Memorial provided mostly private rooms. The decorative artwork, rocking chair, and bureau created a homelike atmosphere. (Courtesy of Health Sciences Library, Baystate Medical Center.)

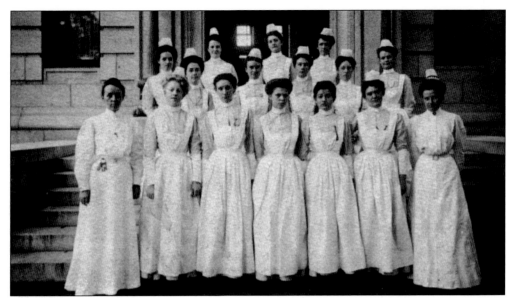

Inpatient nursing care was the province of nursing students operating under the supervision of a small professional nursing staff. Most hospitals supported their own nursing schools, and a three-calendar-year program was established. This 1908 photograph shows the second graduating class of the Wesson Memorial School of Nursing posing on the front steps of the Wesson Memorial Building. In the first 10 years of the school, there were 36 graduates.

This 1922 view of the Wesson Memorial operating room shows the typically large, north-facing window. The surgeons and scrub nurses are gowned, gloved, and masked, but the others present follow a lower level of sterile precautions. The bleachers in the back of the room accommodated observers, generally student nurses or visiting physicians. From left to right are two unidentified, surgeon Dr. Furcolo, anesthesiologist Dr. Grasso (front, without cap), Colton (rear, with cap), Lyons, Corcoran, and R. Hunt.

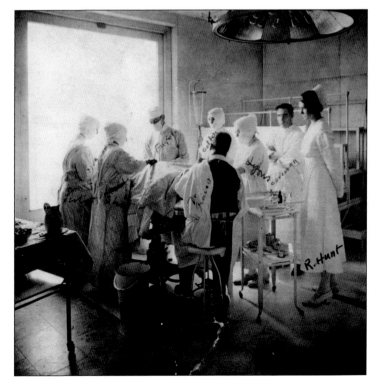

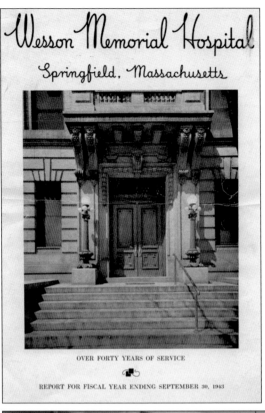

The 1943 annual report featured the main entrance of Wesson Memorial. Three years earlier, the nursing school had closed. A total of 351 nurses graduated from the Hampden Homeopathic and Wesson Memorial Training Schools between 1907 and 1940. (Courtesy of BHM&C.)

This undated photograph captures a morbidity and mortality conference at the Wesson Memorial Hospital in the era before World War II. While the attending physicians are attired in three-piece suits, the presenter, likely an intern, is dressed in scrubs. (Photograph by Paramount Commercial Studios, Springfield, Massachusetts; courtesy of Baystate Medical Archives at the Lyman & Merrie Wood Museum of Springfield History.)

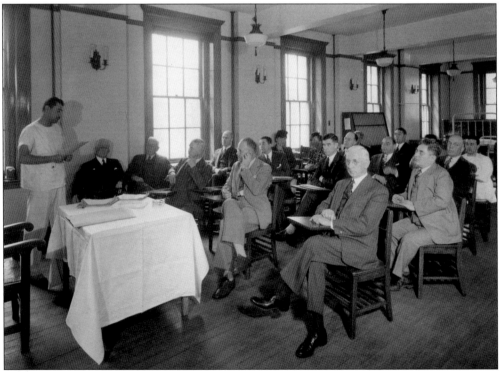

Prior to the 1960s, most hospitals relied on house staff or on-call physicians to cover emergencies. In this c. 1950 photograph from Wesson Memorial, a patient is being sutured.

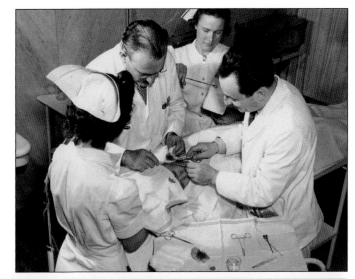

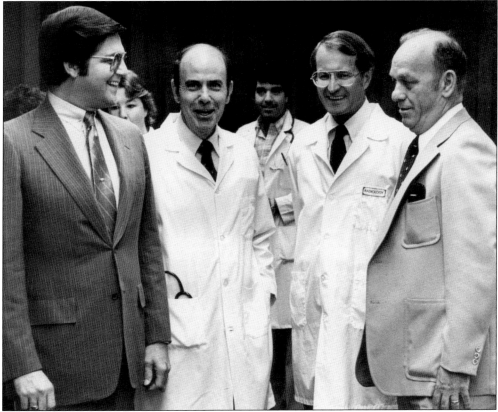

While most acute care hospitals had an emergency room or ward, it was not until the latter half of the 20th century that emergency medicine was recognized as a separate specialty. Facilities expanded from single rooms to large departments. Wesson Emergency Associates was one of the first professional groups nationwide to organize as a department. From left to right are Paul Stagg, director of ambulatory care; Alvin Keroack, MD, director of Wesson Emergency Associates; Max Cloud, MD, radiologist; and William Janes, MD, director of the blood bank.

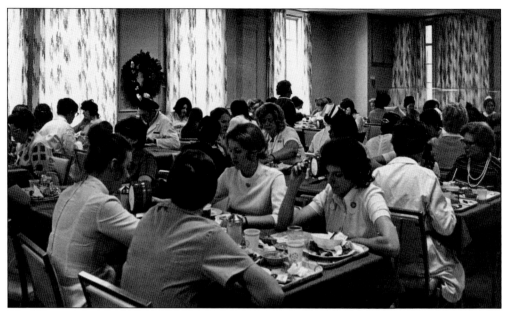

The Wesson Memorial Hospital cafeteria was located on the building's C level, presently the site of the High Street Adult Health Clinic. This 1972 photograph shows Wesson employees enjoying Christmas dinner. In May 1972, hospital capacity was 354, with an average daily census of 280.

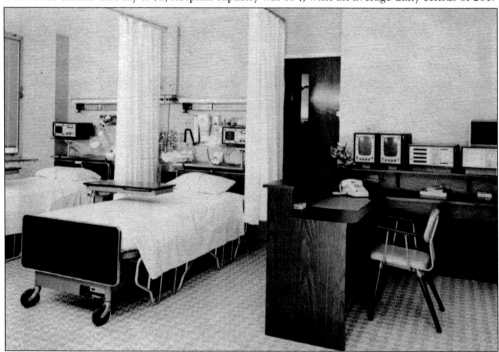

The first intensive care unit in western Massachusetts was opened at Wesson Memorial Hospital in January 1961. Monitoring technology had advanced as a by-product of the telemetry developed by NASA for astronauts and became integral to specialized coronary care units. This is an early-1980s photograph of the coronary care unit at Wesson Memorial. (Courtesy of Health Sciences Library, Baystate Medical Center.)

As medical science advanced, so did the cost of equipment. This photograph shows a cobalt unit used for radiation therapy at Wesson Memorial. The accelerating "arms race" between hospitals to have the latest and greatest in medical equipment would ultimately lead to the merger of Wesson Memorial with Springfield Hospital to become Baystate Medical Center.

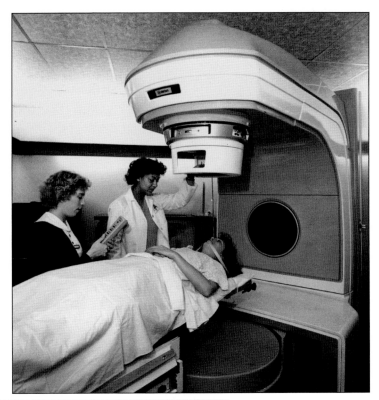

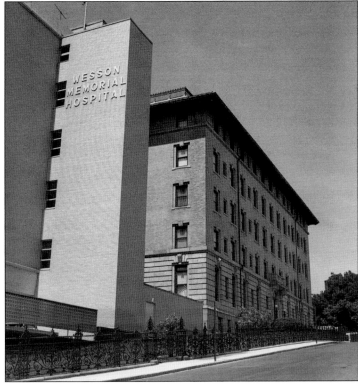

A 1949 addition to the hospital leveled the original Wesson mansion but retained the elaborate wrought iron fence. The new wing provided space for 50 additional inpatient beds as well as an expanded emergency department and outpatient facilities. Due to the slope of High Street, the top five floors were numbered to correspond to the original building, and the four new support levels (A, B, C, and D) were located below the inpatient floors. (Courtesy of BHM&C.)

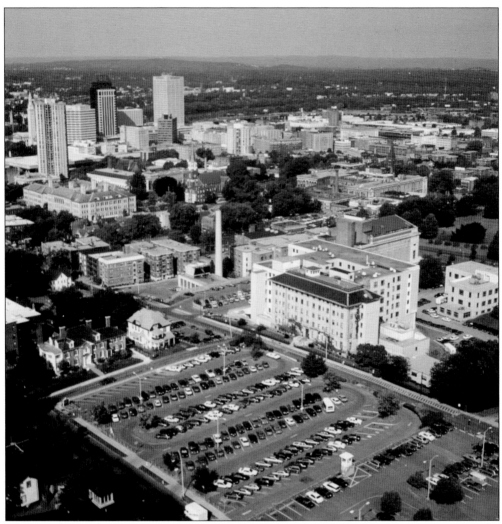

This aerial view shows the complex at 140 High Street, houses on Ingraham Terrace, and the Springfield skyline in the distance. The park across State Street is the lower edge of the Springfield Armory historic site. (Courtesy of BHM&C.)

Three

WESSON MATERNITY HOSPITAL

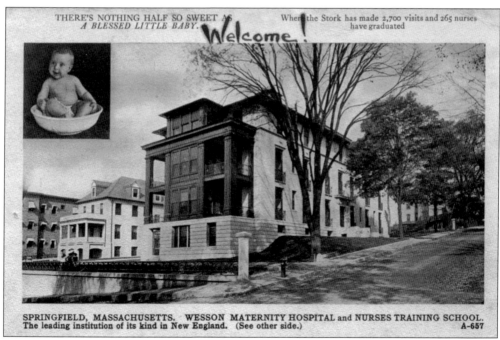

THERE'S NOTHING HALF SO SWEET AS A BLESSED LITTLE BABY.

Welcome !

Where the Stork has made 2,700 visits and 265 nurses have graduated

SPRINGFIELD, MASSACHUSETTS. WESSON MATERNITY HOSPITAL and NURSES TRAINING SCHOOL.
The leading institution of its kind in New England. (See other side.) A-657

In 1906, Daniel Wesson donated over $400,000 for a facility to service the center and south side of Springfield, as St. Luke's Maternity Hospital, Springfield's first maternity hospital, had been acquired by the Sisters of Providence and moved to the North End on the site of today's Mercy Medical Center campus. In 1907, construction began on Wesson Maternity Hospital at the corner of High and Myrtle Streets, about 100 yards downhill from Wesson Memorial Hospital. (Author's collection.)

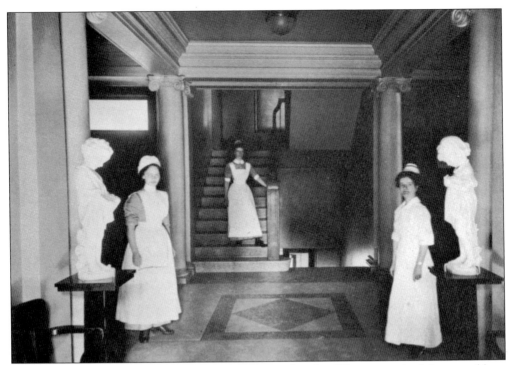

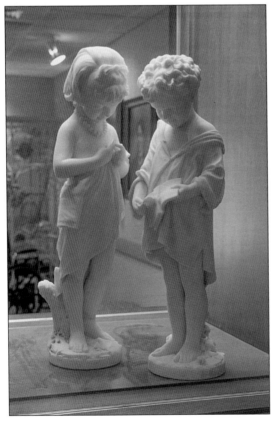

Cynthia Wesson acquired these marble statues, which adorned the lobby of the original Wesson Maternity Hospital, while on a trip to Italy. Dedicated on November 20, 1908, the hospital, as built, contained 25 inpatient beds, plus a nursery. In 1909, the first full year of operation, 293 babies were born there. The cost of care then was $4.63 per day. (Courtesy of Health Sciences Library, Baystate Medical Center.)

Cynthia Wesson's statues eventually made a journey from their initial location on High Street to the second Wesson Maternity Hospital on Chestnut Street, bordering Pratt Street. Today, the statues are displayed in glass cases in the admission area of the third and current home of the Wesson Women & Infants' Unit at Baystate Medical Center. (Photograph by Todd Lajoie; courtesy of BHM&C.)

Wesson Maternity did not have its own nursing school but offered obstetrical nursing training to students from local and regional hospitals. This turn-of-the-century photograph shows five student nurses gathered around a nursing instructor, thought to be Winifred Brooks. By 1914, a total of 265 graduate nurses had received diplomas at Wesson Maternity.

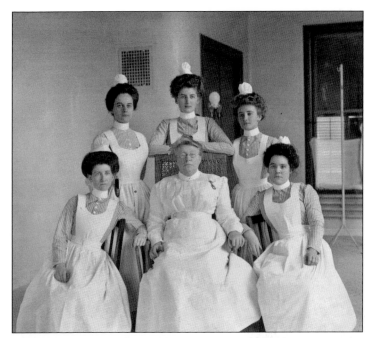

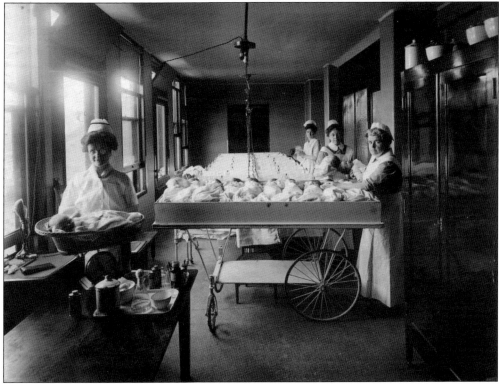

This undated photograph from around 1909 shows babies loaded onto the nursery transport cart. Reportedly, the first eight babies born at the hospital were four girls named Elizabeth and four boys named Robert. After Wesson Maternity opened, Springfield Hospital closed its maternity ward of eight beds and established an affiliation with Wesson for maternity nursing training.

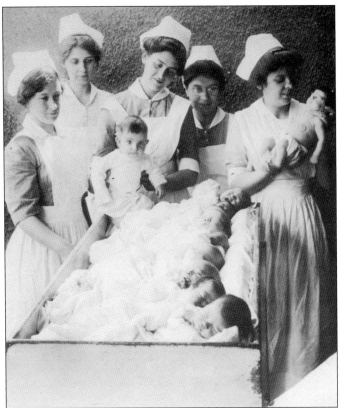

The initial 25 beds of Wesson Maternity Hospital rapidly proved inadequate in number. Single rooms were converted to doubles, and additional beds were placed in the wards. It appears that even the babies were closely packed in the nursery carts.

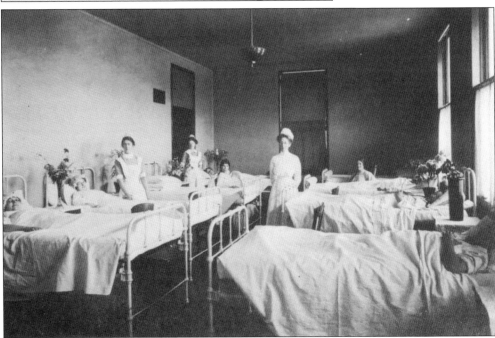

In 1924, the nursery was doubled in size, and a free prenatal clinic was established. This photograph shows a crowded maternity ward. Private rooms were also available.

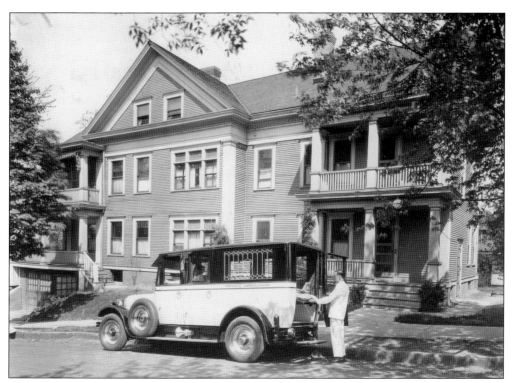

The Springfield City Infirmary was originally located at 89 Belmont Avenue before moving to 1400 State Street, the present location of the Vibra Parkview Facility. In 1933, at the height of the Depression, the Department of Public Works closed the City Infirmary's maternity department and began sending patients to private hospitals, including Wesson. At that time, several private rooms at Wesson became doubles to accommodate the increased demand. Note the elegant ambulance.

In the fiscal year ending 1952, there were 3,353 adult admissions, along with 3,115 births. At that time, the length of stay averaged 7.1 days. A parking lot is visible behind the Wesson Maternity building. The elegant wrought iron fence survives today, but the power plant for the former Wesson Memorial Hospital on High Street now occupies the site.

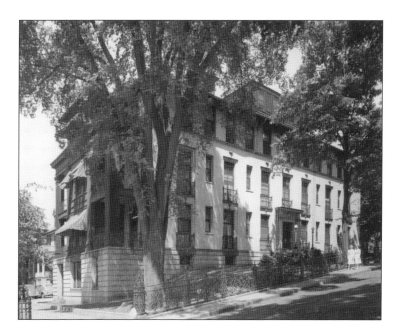

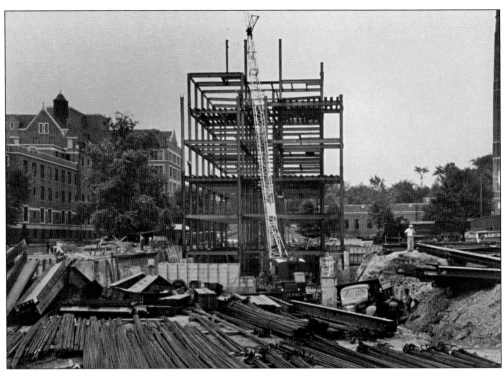

By 1920, the hospital was overflowing beyond capacity. According to annual reports, however, a "birthplace preservation fund," presumably to raise money for new maternity facilities, was not established until 1935. The Depression and lack of fundraising during World War II put plans for a new building on hold. By 1943, a little more than $377,000 had been raised, falling well below the $500,000 goal. In December 1944, Wesson Maternity purchased a tract of land on upper State Street from the city for construction of an $800,000 hospital. Springfield Hospital then offered a location on Pratt Street for a new Wesson Maternity. With funds in short supply, the State Street property was sold to the Springfield Fire & Marine Insurance Company. The sale of nurses' homes and the original hospital building on High Street raised additional funds, and a new 81-bed facility was planned. Construction of the new hospital began in 1951, and it opened on September 15, 1953. (Courtesy of BHM&C.)

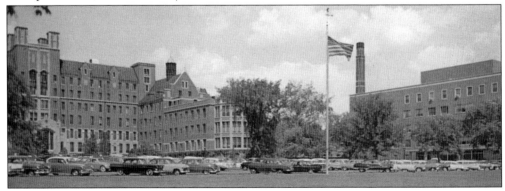

The Wesson Maternity and Springfield Hospitals, connected by a hallway, shared laboratory facilities and other services while remaining distinct corporate entities. This mid-1950s view shows the relationship of the two hospitals and the gradual encroachment of the parking lot on what had been the fields of the Fuller farm. (Author's collection.)

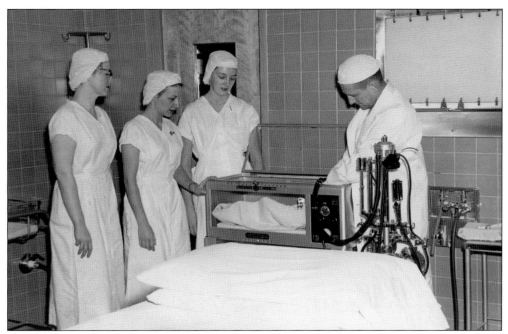

This mid-1950s image shows a delivery room at Wesson Maternity. Attending to a newborn in an incubator are, from left to right, Barbara Harwood, Grace Danforth, Sally Field, and Dr. David Booker.

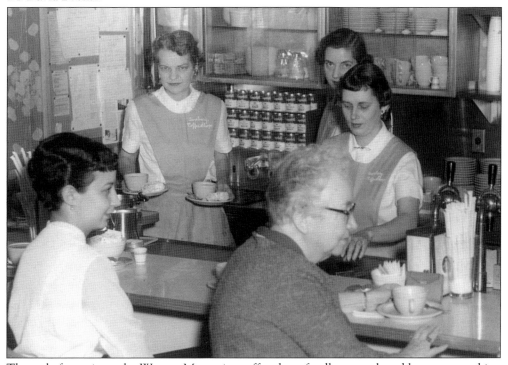

The soda fountain at the Wesson Maternity coffee shop, fondly remembered by nurses working afternoon or overnight shifts, was a reliable source of refreshment when the main cafeteria was closed.

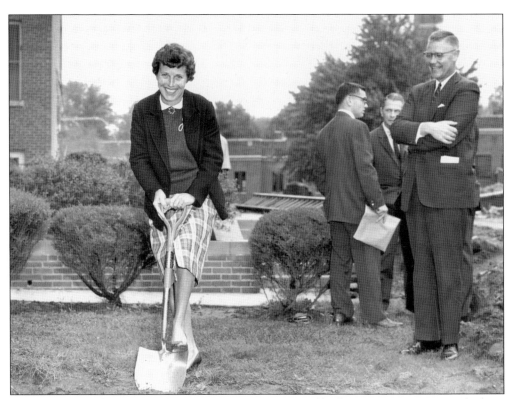

Due in part to the baby boom, the Wesson Maternity Hospital had again outgrown its new facilities only five years after completion. Ground-breaking ceremonies were held on October 8, 1959, to add another 50 beds. From left to right are Jane R. Puffer, Frank Mueller, R.W. Wingate, and Herbert P. Almgren, chairman of the board. Almgren, of the Springfield Fire & Marine Insurance Company, was instrumental in the merger of Wesson Women's with Springfield Hospital Medical Center to form the Medical Center of Western Massachusetts in 1974.

This early-1960s photograph shows the 1953 structure in the center, with the recently completed addition extending from the back of the building toward Pratt Street at right. The style of the new wing closely matched that of the East Building of Springfield Hospital, which can be seen at left. The Chestnut Surgical Center now occupies this site. The smokestack from the powerhouse remains.

The ground-floor entry to the Wesson Maternity Hospital is pictured as it appeared during the 1970s. (Photograph by Vincent S. D'Addario; courtesy of Baystate Medical Archives at the Lyman & Merrie Wood Museum of Springfield History.)

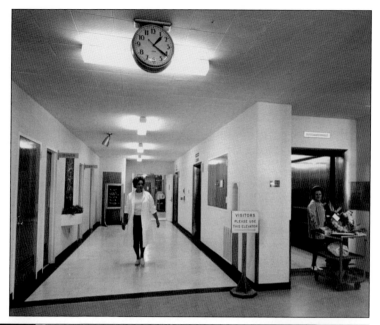

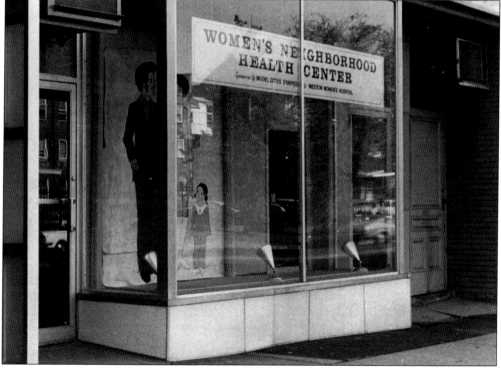

Sponsored by a Model Cities grant and Wesson Women's Hospital, the Women's Neighborhood Health Center opened in April 1970. The initial center was located at 451 State Street in Springfield, then moved to 756 State Street in April 1971. Services began with women's health but eventually expanded. The center was renamed Mason Square Neighborhood Health Center in conjunction with its relocation to the Kennedy-McGoodwin Medical Building at 11 Wilbraham Road in June 1996. (Courtesy of Mason Square Neighborhood Health Center.)

Nurses are pictured at the Wesson 2 nursing station in October 1970. The hospital had recently been renamed Wesson Women's Hospital to acknowledge its provision of gynecology in addition to maternity services. (Photograph by Vincent S. D'Addario; courtesy of Baystate Medical Archives at the Lyman & Merrie Wood Museum of Springfield History.)

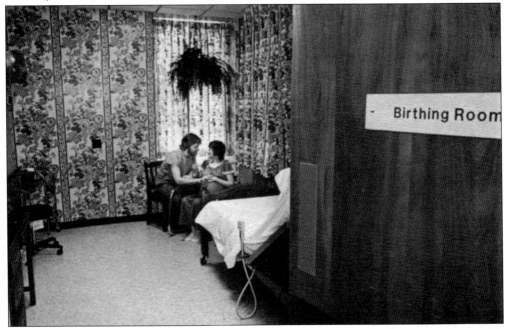

Wesson Women's Hospital was a pioneer in offering birthing rooms. This 1980 photograph shows the dramatic departure from bland hospital walls and a fondness for hanging ferns, as was characteristic of the era.

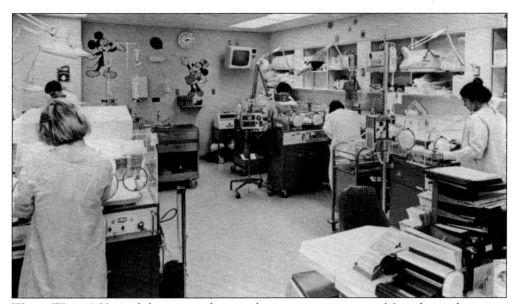

Wesson Women's Hospital also pioneered neonatal intensive care in western Massachusetts beginning in the early 1970s. This 1980 photograph shows the layout of the original neonatal intensive care unit. A decade later, this unit was replaced by a state-of-the-art facility in the new Wesson Wing at Baystate Medical Center. (Courtesy of Health Sciences Library, Baystate Medical Center.)

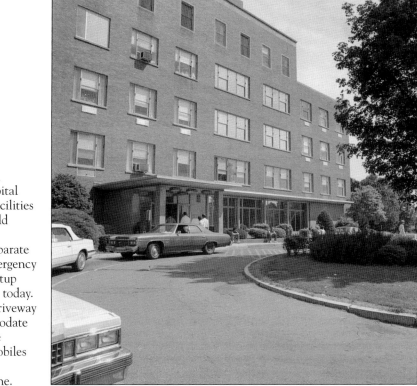

While Wesson Women's Hospital shared some facilities with Springfield Hospital, it maintained separate public and emergency entrances, a setup that continues today. The circular driveway could accommodate several vintage Detroit automobiles from an era of cheaper gasoline.

43

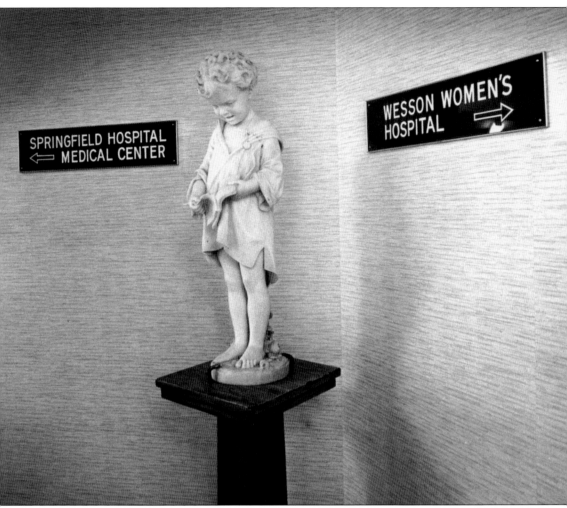

For many years, one of Cynthia Wesson's Italian marble statues graced the hallway connecting Springfield Hospital Medical Center to the Wesson Women's Hospital, while the other was stored for safekeeping. Today, the statues are reunited in a display case in the lobby of the Wesson Women & Infants' Unit.

Four

SPRINGFIELD HOSPITAL IN THE EARLY 20TH CENTURY

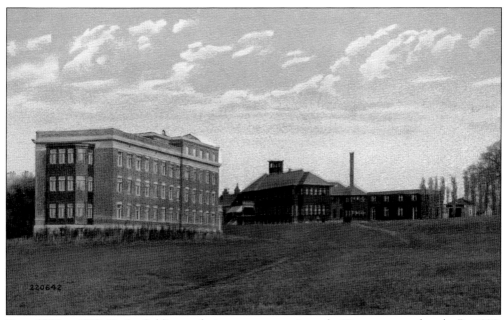

From 1890 to 1930, Springfield's population grew approximately 40 percent per decade. By 1930, the population had approached 150,000, and the city had established a thriving industrial base. To accommodate the ever-increasing number of patients, Springfield Hospital began planning for four new buildings as part of a massive multiyear expansion. This postcard shows the 1915 Chapin Memorial Building at left, which eventually was incorporated as a wing of a new main building. Two wings of the original hospital are visible at right. (Courtesy of BHM&C.)

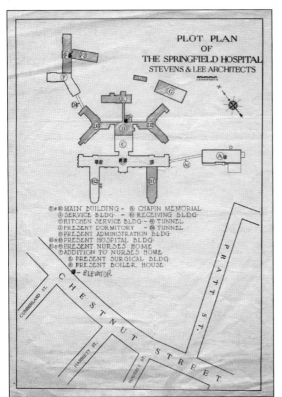

PLOT PLAN
OF
THE SPRINGFIELD HOSPITAL
STEVENS & LEE ARCHITECTS

The architectural firm of Stevens & Lee drew up the plans for the expansion. Four new buildings would more than double the available space for the hospital and nursing school. On the plot plan, Building A is a new power plant, B is the new main hospital, and C is a new service wing. Building F would become the Emily Harris Wing of the nursing school. (Courtesy of Baystate Health Facilities Planning and Engineering.)

The ground-breaking ceremony involved actually digging into the lawn between the hospital and nursing school. The roof and ventilators of the North Wing are visible behind the crowd. This undated photograph is likely from the fall of 1930.

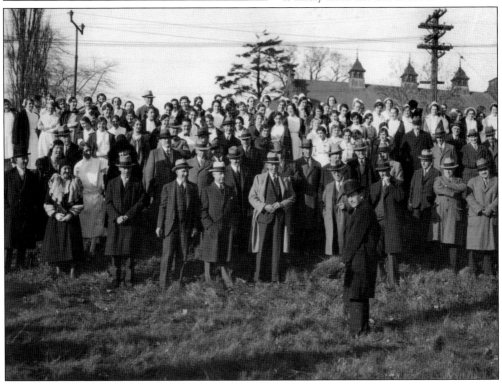

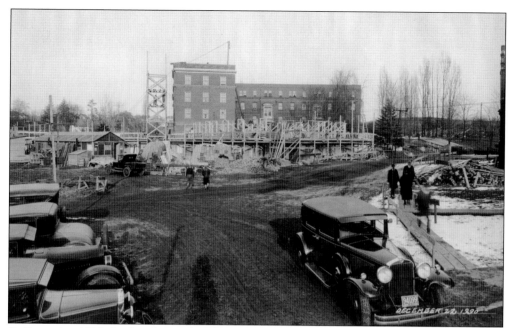

By December 1930, the foundations had been poured, and framing had begun on the Harris Wing. The new nursing residence would be attached to the Porter Building, already connected to the Pratt Building that had lost its original gabled roof with construction of an expanded third floor.

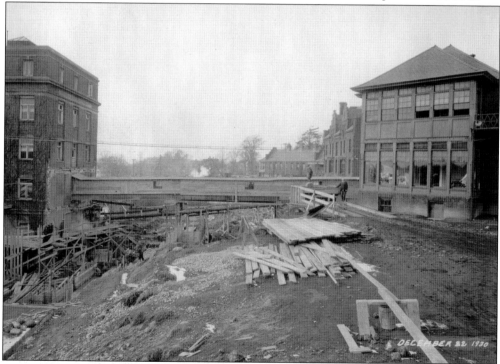

A temporary enclosed passageway spans the excavation for the new main building, known as Springfield Main, between the Chapin Wing (left) and the two-story South Pavilion (right). The main hospital and West Pavilion are visible in the distance of this December 1930 photograph.

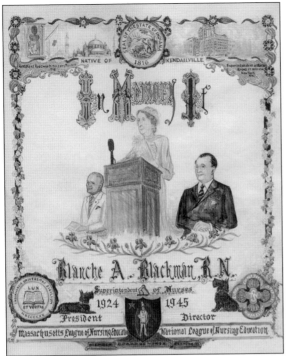

This image was taken from an employee recognition scrapbook commemorating Blanche Blackman, RN, who is featured in the next chapter. The gentlemen on either side of the podium are Dr. Eugene Walker (left), who arrived from Lakeside Hospital in Cleveland, Ohio, in 1931 to become superintendent of Springfield Hospital, and Henry A. Field (right), president of the hospital at the time. Having lost his right arm in an ambulance accident as an intern, Dr. Walker turned from obstetrics to become one of the first physician hospital administrators. He apparently was camera shy, and his image is preserved only in this 1945 pastel by Burpee Craven, a stock clerk and special policemen at Springfield Hospital. Dr. Walker led Springfield Hospital through June 1953. (Courtesy of BHM&C.)

This March 1931 view captures the second floor of the Springfield Building under construction, looking northwest. The brick wall of the existing Chapin Building at left would be removed to incorporate the 1915 structure into the new complex.

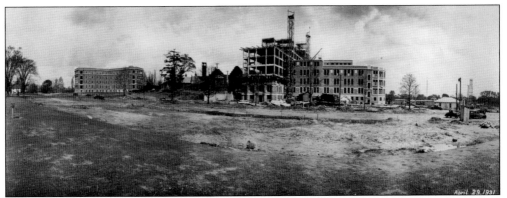

Looking to the east from Springfield Street, this early-1931 photograph shows Springfield Main's steel skeleton under construction, with brickwork nearly complete on the Wright Wing. To the left are the original hospital building and the North and West Wings. The newly built Harris Wing of the nursing residence is also at left. (Courtesy of BHM&C.)

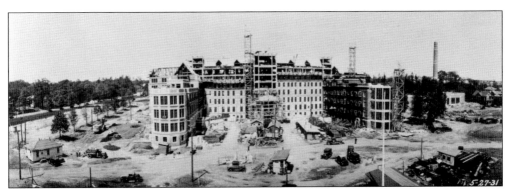

This May 1931 photograph shows construction well under way. The solariums on the existing Chapin Wing (right) have been rebuilt to match the newly constructed Wright Wing (left). The original hospital is now hidden behind Springfield Main. The new power plant and chimney border Pratt Street on the right. (Courtesy of BHM&C.)

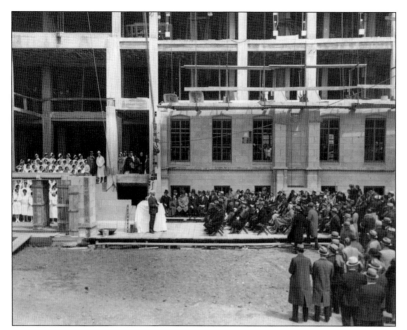

Construction was still under way when nurses and invited guests gathered for the dedication in 1931. Here, the cornerstone is about to be unveiled from beneath the white sheet. (Courtesy of BHM&C.)

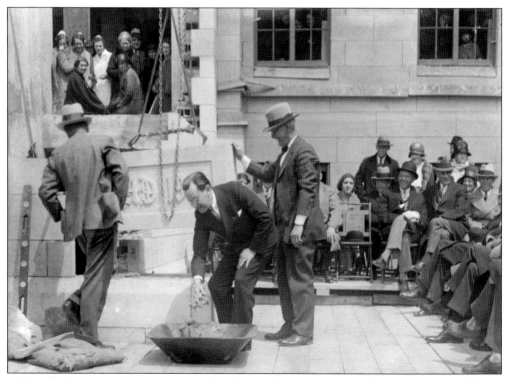

Although the cornerstone was laid in 1931, the new facility was not ready for patients until 1932. The unemployment rate hit 25 percent that year; the additional expense of new beds in the midst of the Great Depression contributed to steadily increasing hospital deficits by 1933. (Courtesy of BHM&C.)

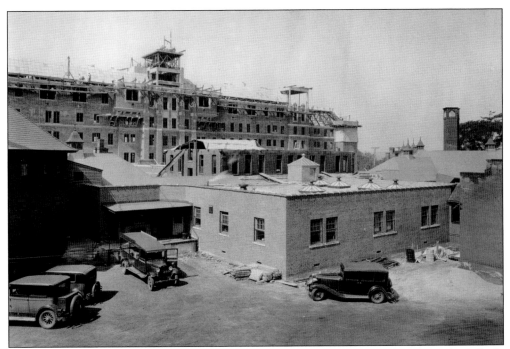

Springfield Main is nearing completion in this May 1931 photograph taken from the hillside northeast of the hospital. In the foreground, an open truck delivers supplies to the loading dock. Just behind the nondescript receiving building is the second floor of the original hospital. The third story and gabled roof have been stripped off, and a tarpaulin protects the interior. As the new Springfield Main was downhill from the original facility, what had been the second floor became the third.

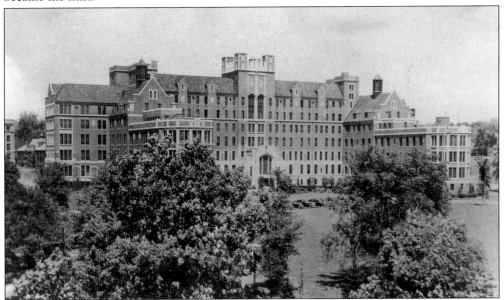

Here, Springfield Main is pictured in the late 1930s. Even then, the fourth floors of the Wright (left) and Chapin (right) Wings were not quite symmetrical. The Wright Wing was extended forward in a later renovation to accommodate an expanded cardiology division.

The main entrance to Springfield Hospital is pictured in the 1930s. The ramp in the foreground extends to the right, allowing wheelchairs to bypass the stairway and access elevators on the ground floor. Aside from additional safety handrails, this view is much the same today. The admitting office was up the stairs and to the right; a waiting room (now the Tom Carr Conference Room) was to the left.

The admitting nurse occupied a desk on the landing between the front entrance and the first floor of Springfield Main. Later, this area became the information booth for the Springfield entrance.

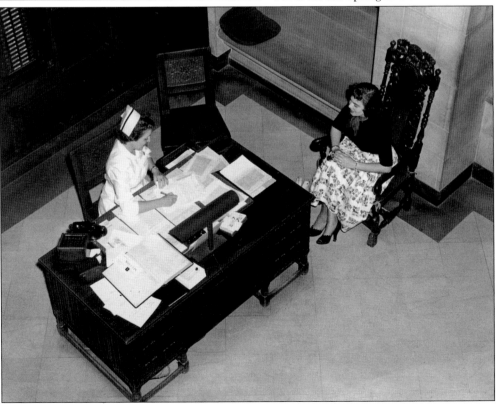

The Outpatient Department was established in 1925 and occupied the ground floor of the Wright Wing after 1932. The new facility increased capacity from 10,000 patients to over 15,000 per year. Indigent and working-class patients without a personal physician were its original clientele. Jennie Dixon, a social worker, arranged nonmedical services for outpatients, including purchasing crutches and providing referrals to nursing homes and other agencies. While the lintel still identifies this building as the "Outpatient Department," this area has subsequently housed medical records, the Critical Care Division, and currently, the Department of Anesthesiology. (Photograph by the author.)

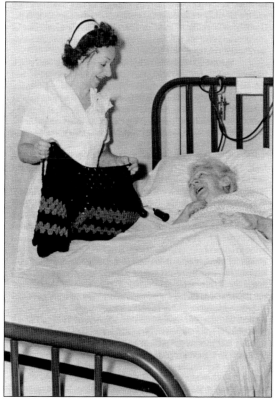

One of Dr. Eugene Walker's first initiatives as superintendent was to create a chronic disease ward on what is currently the Wright Wing of Springfield 3. In its first 10 years of operation, the ward cared for 732 patients, with an average length of stay of 243 days and an occupancy rate of 96.1 percent. Nurse Clo McLean is shown with a patient on the Wright 3 chronic disease ward.

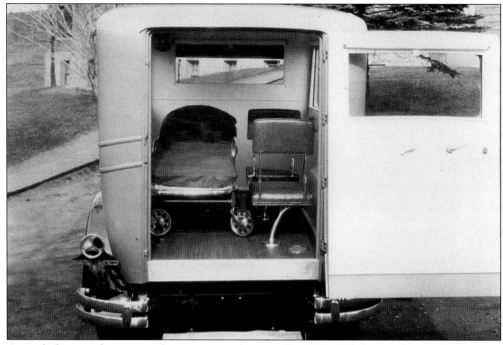

An ambulance is shown near the nursing residence in the 1930s. While stretchers and jump seats would still be familiar, the veritable rolling ICU of equipment in today's ambulances would likely amaze a physician from that era.

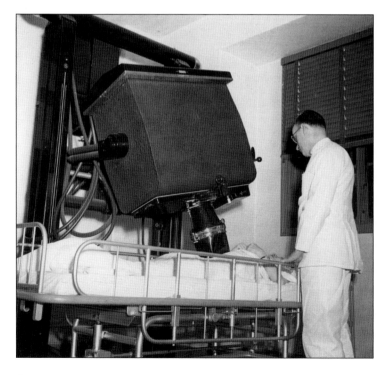

Radiology chief technologist John Lamoureax positions a patient below a massive General Electric 400-kilovolt apparatus for radiation therapy.

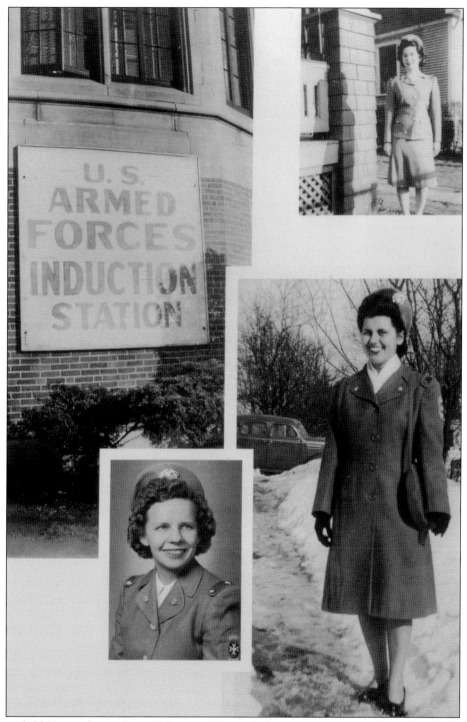

Springfield Hospital served as a US Armed Forces induction station throughout World War II. During the conflict, 111 Springfield Hospital nursing students were enrolled in the Cadet Nurse Corps, including, clockwise from top right, Carolyn Mirkin Levine, class of 1946; Jennie Cascella Manydeeds, class of 1946; and Stacia Godek Egbert, class of 1947.

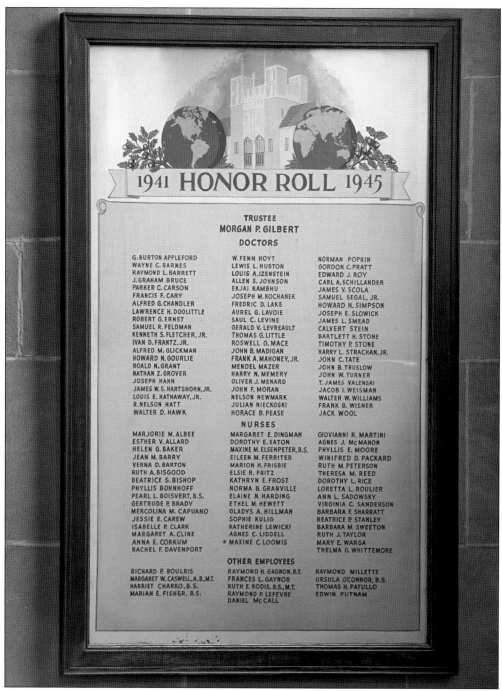

1941 HONOR ROLL 1945

TRUSTEE
MORGAN P. GILBERT

DOCTORS

G. BURTON APPLEFORD	W. FENN HOYT	NORMAN POPKIN
WAYNE C. BARNES	LEWIS L. HUSTON	GORDON C. PRATT
RAYMOND L. BARRETT	LOUIS A. IZENSTEIN	EDWARD J. ROY
J. GRAHAM BRUCE	ALLEN S. JOHNSON	CARL A. SCHILLANDER
PARKER C. CARSON	EKJAI KAMBHU	JAMES V. SCOLA
FRANCIS F. CARY	JOSEPH M. KOCHANEK	SAMUEL SEGAL, JR.
ALFRED G. CHANDLER	FREDRIC D. LAKE	HOWARD N. SIMPSON
LAWRENCE H. DOOLITTLE	AUREL G. LAVOIE	JOSEPH E. SLOWICK
ROBERT G. ERNST	SAUL C. LEVINE	JAMES L. SMEAD
SAMUEL R. FELDMAN	GERALD V. LEVREAULT	CALVERT STEIN
KENNETH S. FLETCHER, JR.	THOMAS G. LITTLE	BARTLETT H. STONE
IVAN D. FRANTZ, JR.	ROSWELL G. MACE	TIMOTHY P. STONE
ALFRED M. GLICKMAN	JOHN B. MADIGAN	HARRY L. STRACHAN, JR.
HOWARD N. GOURLIE	FRANK A. MAHONEY, JR.	JOHN C. TATE
ROALD N. GRANT	MENDEL MAZER	JOHN B. TRUSLOW
NATHAN Z. GROVER	HARRY N. MEMERY	JOHN W. TURNER
JOSEPH HAHN	OLIVER J. MENARD	T. JAMES VALENSKI
JAMES W. S. HARTSHORN, JR.	JOHN F. MORAN	JACOB I. WEISMAN
LOUIS E. HATHAWAY, JR.	NELSON NEWMARK	WALTER W. WILLIAMS
R. NELSON HATT	JULIAN NIECKOSKI	FRANK B. WISNER
WALTER D. HAWK	HORACE B. PEASE	JACK WOOL

NURSES

MARJORIE M. ALBEE	MARGARET E. DINGMAN	GIOVIANNI R. MARTINI
ESTHER V. ALLARD	DOROTHY E. EATON	AGNES J. McMAHON
HELEN G. BAKER	MAXINE M. ELSENPETER, B.S.	PHYLLIS E. MOORE
JEAN M. BARRY	EILEEN M. FERRITER	WINIFRED D. PACKARD
VERNA D. BARTON	MARION H. FRISBIE	RUTH M. PETERSON
RUTH A. BISGOOD	ELSIE R. FRITZ	THERESA M. REED
BEATRICE S. BISHOP	KATHRYN E. FROST	DOROTHY L. RICE
PHYLLIS BOHNHOFF	NORMA B. GRANVILLE	LORETTA L. ROULIER
PEARL L. BOISVERT, B.S.	ELAINE N. HARDING	ANN L. SADOWSKY
GERTRUDE P. BRADY	ETHEL M. HEWETT	VIRGINIA C. SANDERSON
MERCOLINA M. CAPUANO	GLADYS A. HILLMAN	BARBARA F. SHARRATT
JESSIE E. CAREW	SOPHIE KULIG	BEATRICE P. STANLEY
ISABELLE P. CLARK	KATHERINE LEWICKI	BARBARA M. SWEETON
MARGARET A. CLINE	AGNES C. LIDDELL	RUTH J. TAYLOR
ANNA E. CORKUM	★ MAXINE C. LOOMIS	MARY E. WARGA
RACHEL F. DAVENPORT		THELMA G. WHITTEMORE

OTHER EMPLOYEES

RICHARD P. BOULRIS	RAYMOND H. GAGNON, R.T.	RAYMOND MILLETTE
MARGARET W. CASWELL, A.B., M.T.	FRANCES L. GAYNOR	URSULA O'CONNOR, B.S.
HARRIET CHARKO, B.S.	RUTH E. KODIS, B.S., M.T.	THOMAS H. PATULLO
MARIAN E. FISHER, B.S.	RAYMOND P. LEFEVRE	EDWIN PUTNAM
	DANIEL McCALL	

During World War II, 63 physicians, 47 nurses, 13 other employees, and a trustee of Springfield Hospital served in the Armed Forces and were recognized with an honor roll that still graces the Springfield entrance lobby. The war effort proved beneficial to local arms manufacturers, and employment boomed. Many of these jobs provided company-sponsored insurance plans, which eventually translated to a brighter financial picture for Springfield Hospital as health insurance became common. (Photograph by Todd Lajoie; courtesy of BHM&C.)

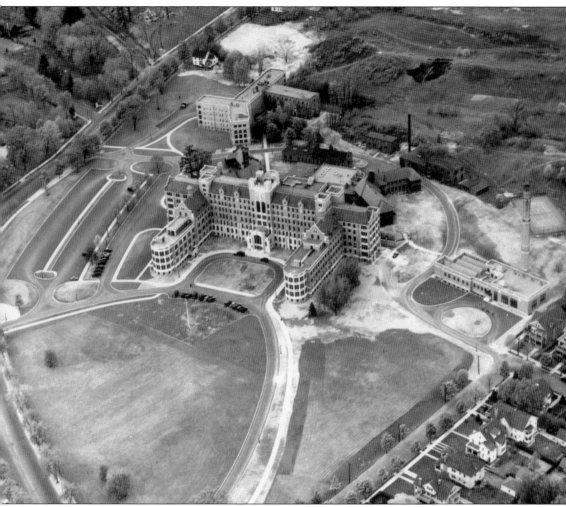

At the center of this 1938 photograph is the new Springfield Building, appearing much the same as it does today. Just behind it are the original hospital building (minus its gabled roof), two service buildings, and the original four wards jutting off at 45-degree angles. The nursing school has added the angled Harris Building to the older Porter Wing and vintage Pratt Building. A new building housing the laundry and power plant borders Pratt Street, separated from the old factories by a tennis court. In the upper left corner, streetcar tracks turn off Springfield Street and onto a private right-of-way through the Atwater neighborhood.

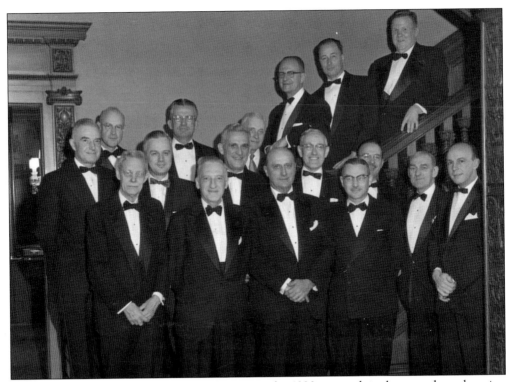

The Colony Club catered to the city's elite. From the 1920s onward, it also served as a location for Springfield Hospital medical staff meetings, which featured dinner, a report from the medical staff president, and scientific presentations on medical topics. The tuxedo attire in this undated photograph of the Springfield Medical Club suggests a more formal event. From left to right are (first row) Drs. Lawrence Chapin, Roderick Macauley, Stanley Stusick, W. Fenn Hoit, Ross Mace, and Harry Memery; (second row) Drs. James Smead, Harry Strachan, Paul Sanderson, L.H. Doolittle, and Leonard Anderson; (third row) Drs. Al Johnson, John Turner, and Alan Rice; (fourth row, on stairs) Drs. Wayne Barnes, Howard Simpson, and Parker Carson.

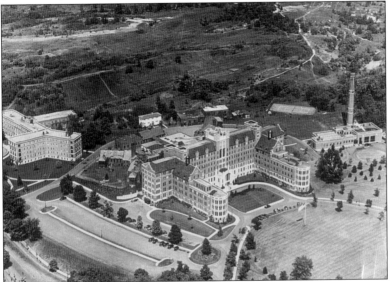

The wings of the original hospital, including the rarely pictured surgical pavilion to the rear, are looking worn in contrast to the newly completed expansion project. Note the tennis court behind the power plant. The hillside above the hospital has yet to be developed.

Five

SPRINGFIELD HOSPITAL SCHOOL OF NURSING

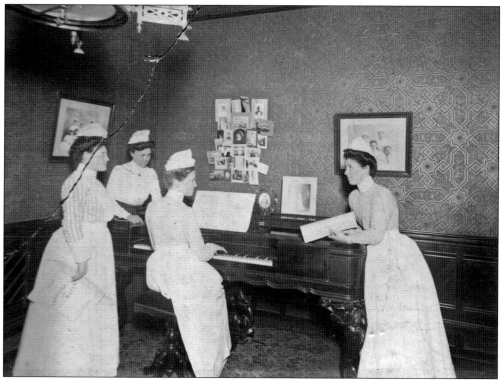

As early as 1869, hospital trustees were interested in having a school of nursing, but it was not until 1892 that the Springfield Hospital Training School first admitted young women preparing to enter the field. Nursing students were initially housed on the top floor of the main hospital building, where noise proved to be problematic. The attic space was also reportedly too hot in the summer and too cold in the winter. This photograph shows student nurses gathered around a piano in 1903. (Courtesy of Health Sciences Library, Baystate Medical Center.)

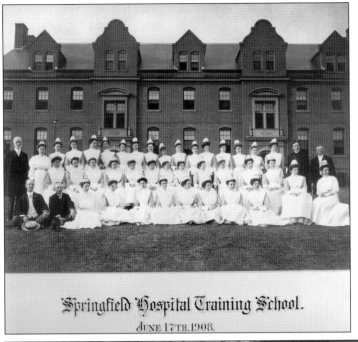

Springfield Hospital Training School.
JUNE 17TH. 1908.

On June 17, 1908, nurses and staff attended a graduation ceremony held outside the Pratt Building, which was dedicated in 1906 to Lucinda Howard Orne Pratt, mother of George Dwight Pratt, president of the board of trustees and generous donor to the project. The Pratt Building provided living accommodations and dormitory space for nursing students previously housed in the attic of the main hospital building.

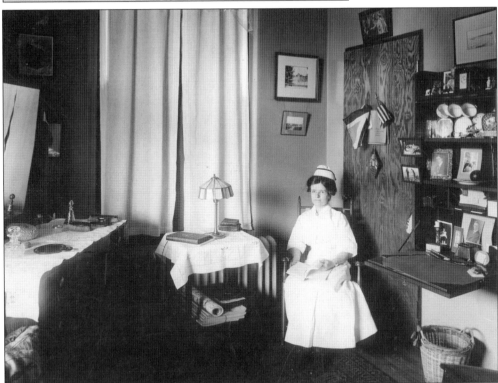

This undated photograph shows a nursing student in a dormitory room of the Pratt Building, which was equipped with living, dining, and study areas, as well as shared bathroom facilities. The Porter (1924) and Harris (1931) Wings were connected to the 1906 Pratt facility as the nursing training program expanded.

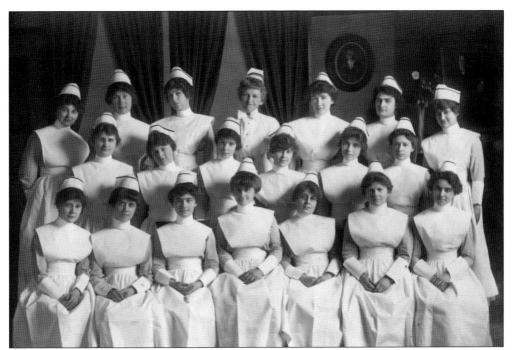

Graduating from the Springfield Hospital Training School in 1917, these nurses are dressed in starched whites and traditional hats.

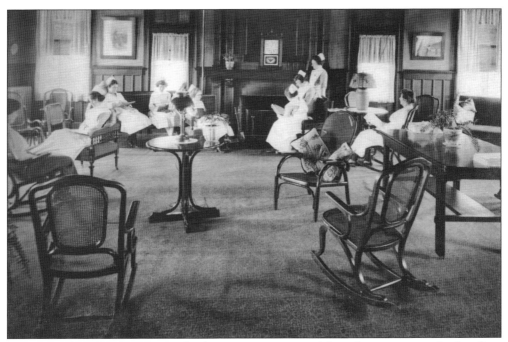

Nursing students lived on campus for the two-year program. A large living room on the first floor of the Pratt Building provided a place to read. Dormitory rooms occupied the upper floors.

In 1924, Blanche Blackman became superintendent of the Springfield Hospital Training School. She had previously served in Crimea during World War I. During her 21-year tenure at the hospital, nursing school enrollment increased, and work-hour restrictions led to the employment of graduate nurses to handle tasks previously managed by students. Springfield students were allowed to rotate at three affiliated hospitals: Wesson Maternity Hospital; Contagious Hospital in Providence, Rhode Island; and McLean Hospital in Belmont, Massachusetts, for mental health nursing. (Courtesy of Health Sciences Library, Baystate Medical Center.)

During Blanche Blackman's tenure, the overall size of the nursing faculty changed very little, remaining between 18 and 20. Members included an assistant superintendent, a night supervisor with an assistant, a supervisor of the Chapin Building with an assistant, two charge nurses in Chapin, and three charge nurses for the main hospital. There were also instructors of nursing techniques and the science of nursing, as well as a supervisor for preliminary students on the wards. Physicians lectured on medical, surgical, and specialty subjects. Students continued to serve as the primary source of care for patients, a practice that did not change until after World War II. This undated photograph shows Blackman and several of her colleagues in the cafeteria line. Blanche Blackman retired in 1945 after serving as superintendent of nursing since 1924. (Courtesy of Health Sciences Library, Baystate Medical Center.)

A nearly 100-year holiday tradition involved nursing students caroling for hospitalized patients. The oil lamps in this 1948 photograph later gave way to electric candles for safety reasons. (Photograph by Arthur J. Scott; courtesy of Baystate Medical Archives at the Lyman & Merrie Wood Museum of Springfield History.)

Following their hospital training, many nurses went on to work as visiting nurses, providing care in homes and conducting health screenings in the community. (Courtesy of BHM&C.)

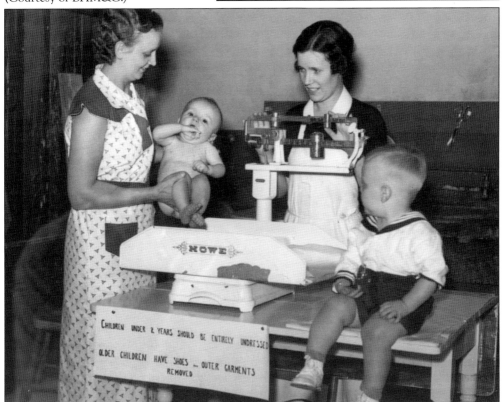

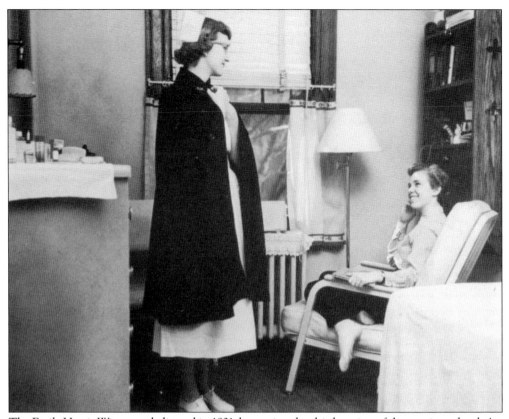

The Emily Harris Wing was dedicated in 1931, becoming the third section of the nursing school. An additional 88 dormitory rooms, plus classrooms and laboratories, helped to relieve overcrowding. In this later picture, the seated nursing student is Bette Ryan, who served as the model for the bronze statue outside the Chestnut Building that commemorates the school of nursing.

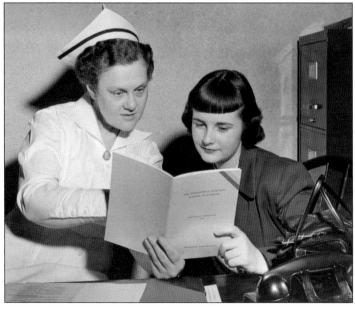

Margaret Busche, RN, reviews the information circular for the Springfield Hospital School of Nursing with student Beverly Dorey in this 1952 photograph.

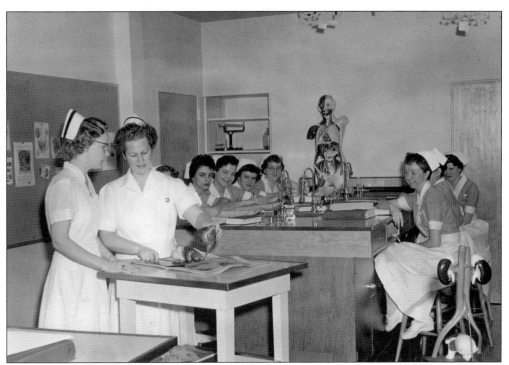

Nursing instruction took place in the Pratt-Porter-Harris complex, as well as within the hospital. The nursing arts classroom was located near the auditorium on Service 3. In this picture, Jane Crandall (left) and Barbara Bates (second from left) prepare a demonstration for students in 1955.

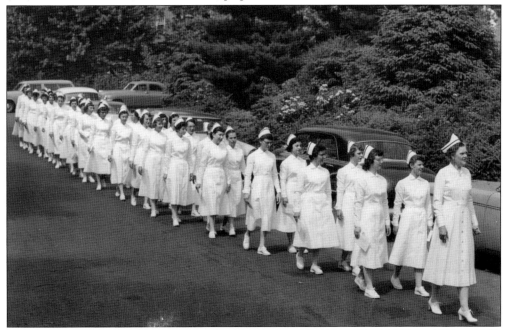

Nurses are shown marching in their graduation ceremony on June 15, 1956. From 1933 to 1960, graduation exercises were held outside on hospital grounds. Remarkably, in those 27 years, there was never a rainout.

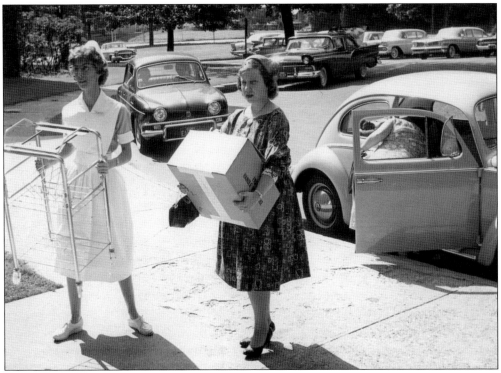

All incoming nursing students were assigned a "big sister." This photograph from 1961 shows big sister Judith Oberlander and freshman Carol Twining unloading personal belongings. A circular drive occupied the space in front of the Porter and Harris Wings of the nursing school.

In this September 1961 photograph, Frances Fontaine (left) and Catherine Denault (right) welcome freshman Carolyn DeLong (center).

Rooms in the Porter-Harris Building were single occupancy and large enough to accommodate a bed, a desk, and a comfortable chair. The rooms featured closets and sinks, with communal bath and toilet facilities located down the hall.

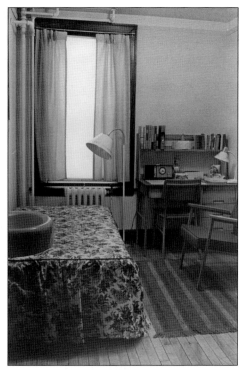

A 1962 brochure for the nursing program featured this photograph of the music room and its high-fidelity record player. The music room was located on the first floor of the Pratt Building.

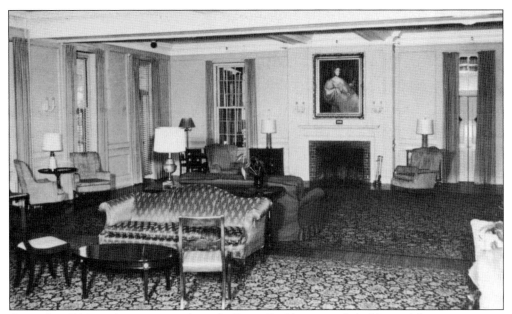

Opened in 1924 to relieve overcrowding, the Porter Building provided additional dormitory rooms, classroom facilities, and a large elegant living room. The oil painting over the fireplace honors Emily Harris (1852–1940), who was a trustee of Springfield Hospital and president of the affiliated Aids and Charities organization. She provided funds for two wings of the nurses' residence at Springfield Hospital. After the nursing school closed in 1999, this room continued to be utilized for hospital events and was known informally as the "rug room" due to its surviving Oriental carpets, which had been purchased with penny sale funds raised by nursing students after World War II. The doors on the right behind the curtains connected to the later Harris Wing.

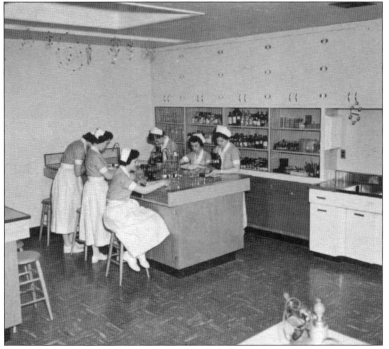

The nursing school science lab, seen here in 1962, was located on Service 3, where security currently occupies the space beneath the skylights. Note the models of molecules hanging from the ceiling.

The service building behind Springfield Main encompassed the original hospital, plus later additions; its third floor featured one large and one small auditorium, primarily used for nursing instruction but also for medical staff conferences.

In this 1962 view, the front half of the larger auditorium is seen. The windows to the left were boxed in during the construction of a six-story hallway connector between the Springfield and Centennial (now Daly) Buildings. Once new conference facilities opened in the Chestnut Building, the auditorium was converted first to an ER holding area and then to office space for the Hospital Medicine Program.

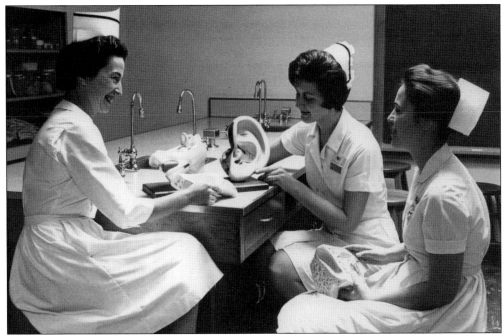

A nursing instructor demonstrates the auditory system with a model of a giant ear. Springfield Hospital School of Nursing (formerly Springfield Hospital Training School) recruited many students from local high schools. As a hospital-based program, the school of nursing received support from the American Hospital Association and the Massachusetts Hospital Association. (Courtesy of Health Sciences Library, Baystate Medical Center.)

This 1962 photograph shows members of the nursing school whose birthdays fell in March. They have been identified on the back of the image as follows: (from left to right) Carol Mercier, Barbara Herzig, Sandra Mackay, Barbara Kopec, Joan Ickrath, Dianna Ortner, Martha Johnson, Pauline Chapdelaine, and Carolyn Delong.

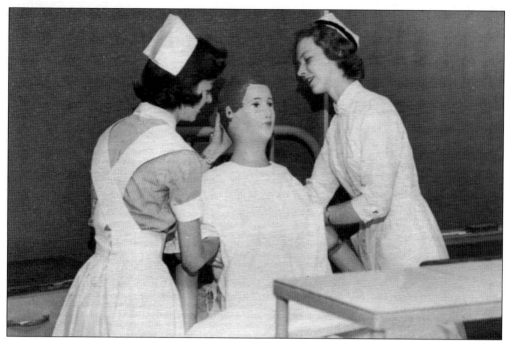

Today's highly realistic patient simulators have their roots in less sophisticated early models such as this. Here, two student nurses adjust a patient. Unconfirmed reports suggest that the simulated patient, nicknamed "Mrs. Chase," could often be found in hilariously unexpected places in the Porter-Harris and Pratt Buildings.

Nurses in training did not receive their caps until midway through their freshman year. This picture from the 1962 nursing school brochure commemorates this important milestone in a student's career. One or two narrow stripes identified students with more seniority, and a broad stripe on the cap marked a graduate. (Courtesy of Health Sciences Library, Baystate Medical Center.)

Although men had long served as nurses in the military and religious orders, they were expected to fight in the conflict during World War I. Nursing became an almost exclusively female profession for a half century, and men were not allowed into most nursing schools. As the first male graduate of the Springfield Hospital School of Nursing, William Malone was well ahead of his time in 1971. Following a 1982 US Supreme Court ruling on gender discrimination, men began to reenter the profession in larger numbers.

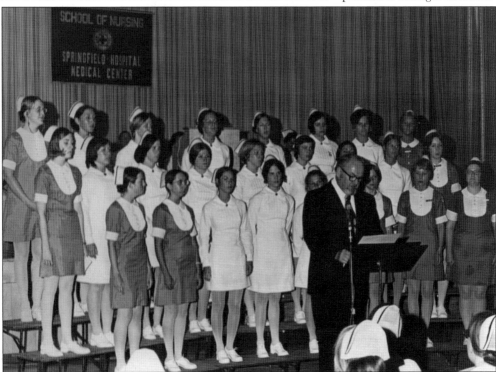

Despite long-standing luck with the weather, it was decided not to risk the chance of rain during graduation ceremonies after 1960. Class sizes were larger, with several guests per graduate; thus, ceremonies were moved from the Springfield Hospital grounds to various venues, such as the Springfield Municipal Auditorium, pictured here on June 10, 1973. By then, the school had become a commuter program, no longer offering housing. An alliance with Springfield Technical Community College offered students the opportunity to take additional courses leading to a baccalaureate degree. (Photograph by Laurence K. Black; courtesy of Baystate Medical Archives at the Lyman & Merrie Wood Museum of Springfield History.)

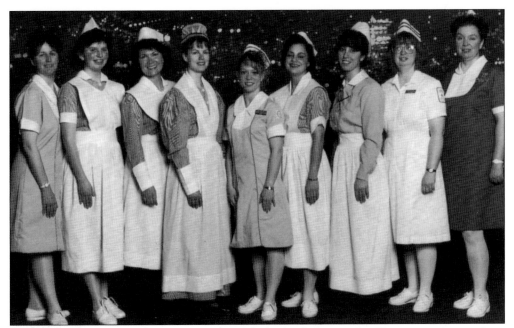

Initially, nursing uniforms and caps were modified nuns' habits, and in Europe, nurses wore long caps that covered most of their hair. In North America and the United Kingdom, a short cap sitting atop a nurse's head was more common. Students model a variety of historical uniforms in this 1980s photograph. By then, starched white uniforms had given way to scrubs, and nurses' caps had all but disappeared.

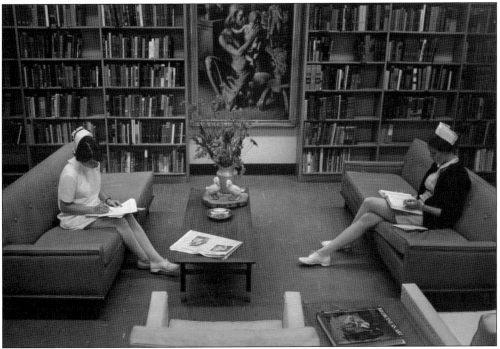

The reading room at the Springfield Hospital library is pictured in 1970. Note the ashtrays on the coffee table and next to the nurse on the right.

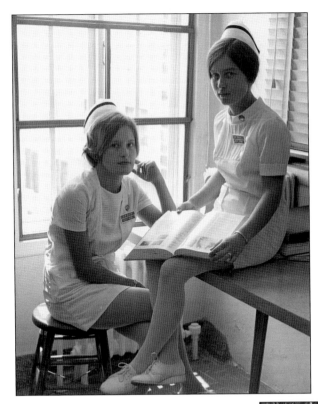

Sue Slater (left) and Ellen Hartwell are working to complete their ICU training in this undated photograph. By the 1990s, nursing education had shifted from hospital-affiliated programs to baccalaureate programs awarding a bachelor of science in nursing (BSN). The Baystate School of Nursing closed in 1999, having graduated 2,906 students during 107 years at Baystate Medical Center and its predecessors, including Springfield Hospital, Wesson Maternity Hospital, and Wesson Women's Hospital.

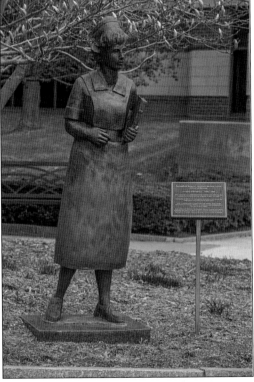

The Springfield Hospital/Baystate Medical Center School of Nursing is commemorated with a statue and plaque outside the Chestnut Building. Married to sculptor Arthur Moses, Bette Ryan Moses, pictured earlier in this chapter, served as the model for this bronze statue. (Photograph by Todd Lajoie; courtesy of BHM&C.)

Six

THE POSTWAR YEARS

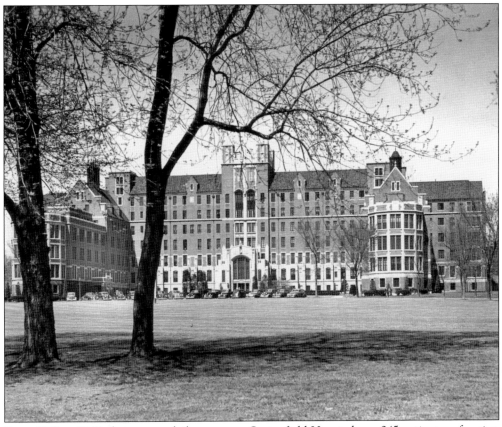

From 1945 to 1947, the average daily census at Springfield Hospital was 245 patients, a fraction of the more than 700 inpatients accommodated today.

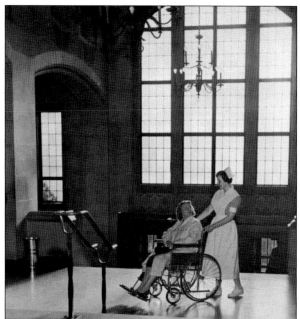

A student nurse wheels a patient through the entryway of Springfield Hospital, now the Springfield Building at Baystate Medical Center. This early-1960s photograph was clearly staged for a brochure since the wheelchair would have had to navigate stairs down to the entrance or up to the first floor. A ramp to the left of the picture more conveniently accommodated patients in wheelchairs. (Courtesy of Health Sciences Library, Baystate Medical Center.)

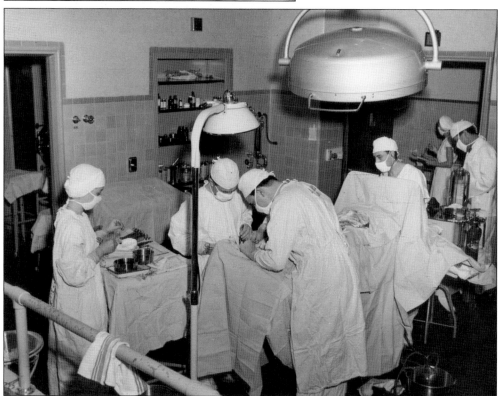

One of the large operating rooms on the sixth floor is pictured around 1960. Two of the eight operating rooms had observation galleries, the railing of which can be seen in the lower left corner of the picture. By the postwar era, gowns, masks, and head protection were more in line with contemporary standards.

Dr. James B. Scola was long retired when this photograph appeared in the *Springfield Union News* in 1988 to commemorate the first kidney transplant in the United States, which was performed on March 31, 1951, when Dr. Scola was chief of surgery. With kidneys destroyed by nephritis, a 37-year-old boiler repairman had been referred to Dr. Scola. Another patient required removal of a healthy kidney and ureter to treat cancer of the upper bladder and lower ureter. The two patients were set up in adjoining operating rooms, and initially, the operation was successful. However, the problem of tissue rejection was not well understood, and Dr. Scola's patient died in May, surviving only six weeks after the operation. This issue was not solved until 1954, when a kidney donated by an identical twin to his brother gave insight into the phenomenon of tissue rejection. (Courtesy of Health Sciences Library, Baystate Medical Center.)

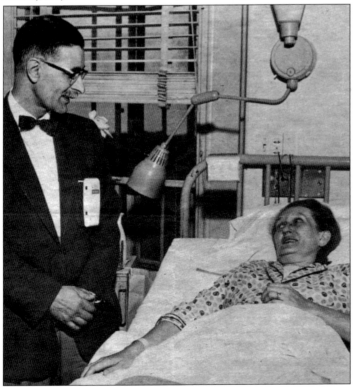

Dr. James Scola, then surgeon in chief of Springfield Hospital, is shown visiting Mrs. Frank Petras of West Springfield in this photograph, which originally appeared in the *Springfield Sunday Republican* on July 10, 1960. The large device hanging from Dr. Scola's jacket pocket is an early pager. (Courtesy of Health Sciences Library, Baystate Medical Center.)

The admitting office, seen here in 1960, was located on the first floor of what is now the Springfield Building. From left to right are Ann Ryan, the admitting officer; Dr. Harry Strachan, chief of anesthesiology; and Dr. Jerome Whitney, a neuropsychiatrist.

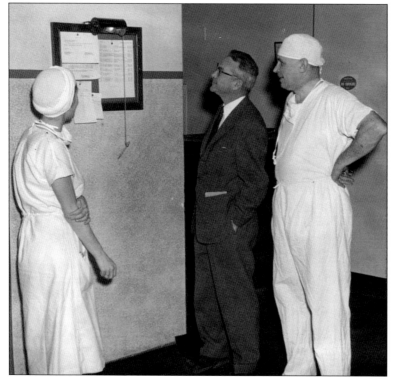

From 1932 to 1986, the main surgical pavilion occupied the sixth floor of Springfield Main. Checking the operating room schedule are, from left to right, Jane Markham, Dr. Fenn Hoit, and Dr. Theodore Miner.

Helen Visnaw, RN, is pictured in the operating room corridor on Springfield 6. Today, this extensively remodeled floor houses adolescent medicine.

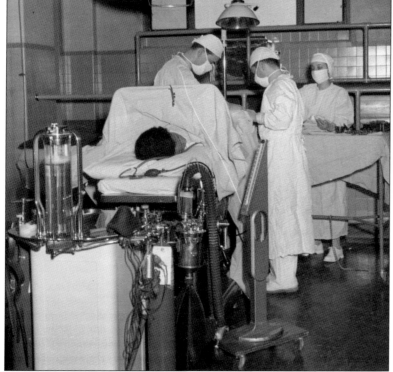

Surgery is in progress, apparently under local anesthesia, in this mid-1960s photograph of an operating room on Springfield 6. The viewing gallery, although empty, is clearly visible.

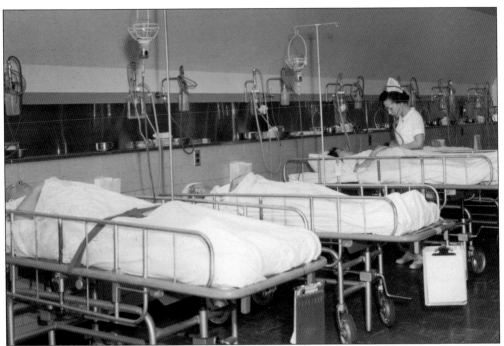

The main recovery room was located on Springfield 6, from 1932 until the new post-anesthesia care unit (PACU) opened in the Centennial (now Daly) Building in 1986. This area is not in routine clinical use today but can be used as an overflow ward in times of high census. Mrs. Roland Malo, RN, tends to a patient in this 1956 photograph.

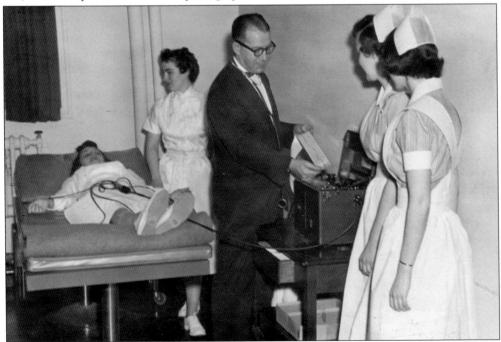

Dr. Jacob Weisman displays the tracing of an electrocardiogram (EKG) to student nurses in this undated photograph.

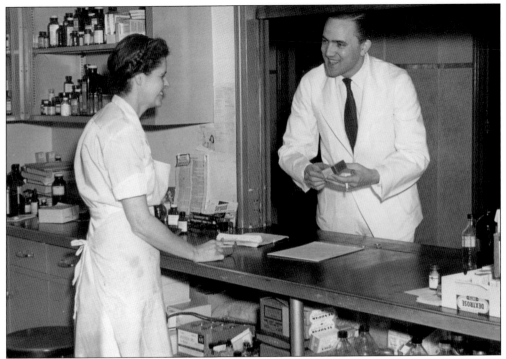

The period following World War II was characterized by intense biomedical research in the creation of many new options for pharmacotherapy. This mid-1950s photograph shows Esther Clark and Dr. Sante Caldarola in the pharmacy.

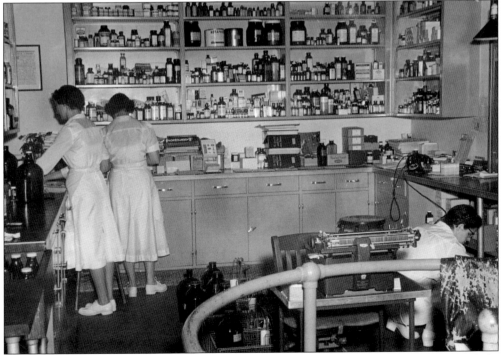

From left to right are inpatient pharmacy staffers Barbara Kuhn, Josephine Zabes, and Esther Clark.

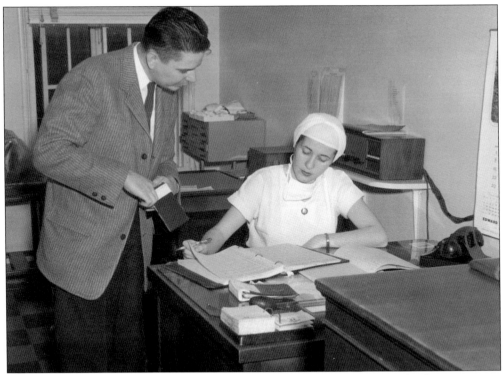

Dr. John Prybylo schedules an operation with Jane Markham, a nurse in OR booking.

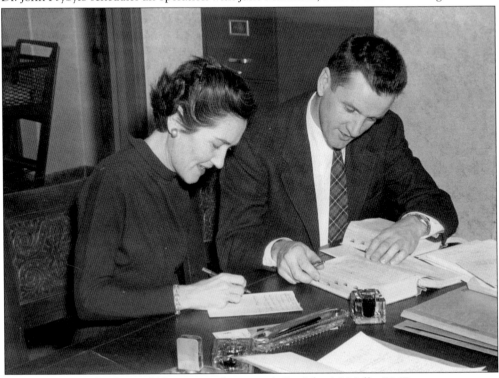

Hazel Brown, medical record librarian, is shown with Dr. John McNally, DMD.

Visitors arrive at the entrance to Springfield Main in 1955. The facade has since been altered with the addition of an enclosed shelter.

A true marker of success is sending a patient home in an improved state of health. This 1955 photograph was taken on the steps of the main hospital before the present-day glass shelter was constructed. The woman at center is identified as secretary Ida Lawton, but the others are unidentified.

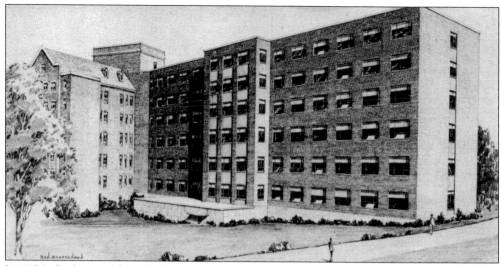

In 1956, the hospital launched a fundraising drive to support construction of a 150-bed wing attached to the east corner of the main hospital. The East Wing of the original hospital had occupied this site. Constructed with a steel frame and equipped with modern facilities, the new building would be six stories, plus ground and basement levels. This structure survives today as the East Wing. Although patient care is gradually moving out of this building, it currently houses medical wards on Springfield 1, 2, and 3. This architectural rendering dates from 1956. Because of construction and labor shortages, the building was not opened until 1959. (Courtesy of Health Sciences Library, Baystate Medical Center.)

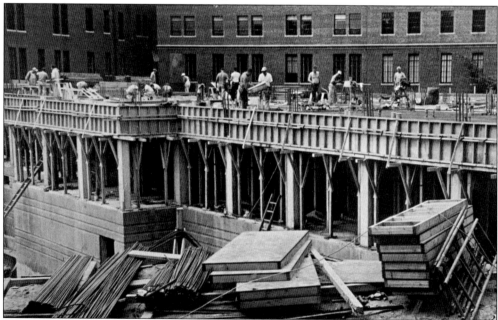

The foundation has been poured and framing is in progress for the East Building in this 1958 construction photograph. Springfield Main is to the left. Behind the construction, the cafeteria occupies the second floor, with the auditoriums on the third floor. From left to right, the first nine windows are part of the 1931 building project, while the last four (of five total) correspond to the original 1889 hospital. (Courtesy of Health Sciences Library, Baystate Medical Center.)

84

The hand-cranked beds in this photograph help date the picture to between the late 1950s and the early 1970s. The sign indicating "this is a typical 2 bed room" suggests that it might have been a tour following the opening of the addition to the Wesson Maternity Hospital in 1960 or the East Building in 1959. (Courtesy of Health Sciences Library, Baystate Medical Center.)

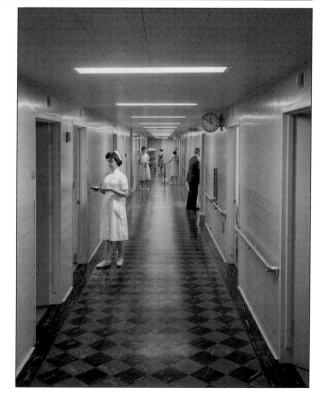

The East Building was dedicated in 1959, but staffing was insufficient to open all five floors immediately. By 1961, Chapin 2, 3, 4, and 5 had been closed, and patients were transferred to the new wing. East 5 is seen at right shortly after it opened. This floor was decommissioned when heart and vascular services were relocated to the 2012 MassMutual Wing.

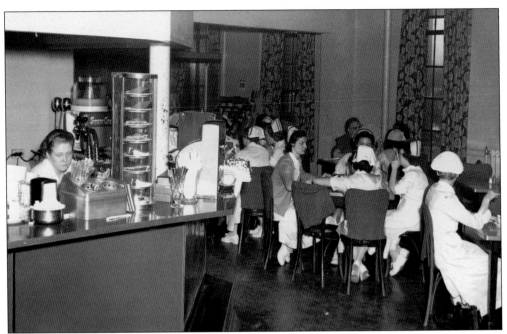

Then, as today, the cafeteria was located on the second floor of the original hospital. Over time, the cafeteria's footprint expanded with the additions of the service building and then the Centennial (now Daly) Building. Today, this counter is long gone; utensils and condiments are dispensed from the area in front of the closest window.

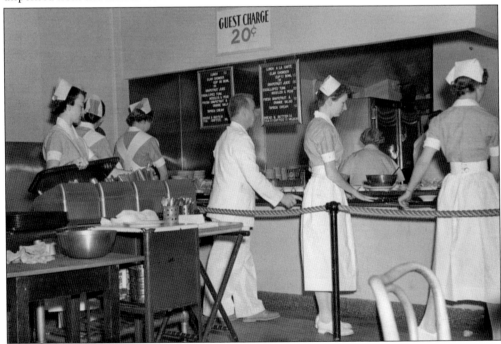

Student nurses line up for lunch. The special included an interesting choice between clam chowder or grapefruit juice, an entrée of escalloped tuna with noodles and peas, a fresh grapefruit and orange salad, bread and butter, and tapioca cream, along with tea, coffee, or milk—all for 50¢.

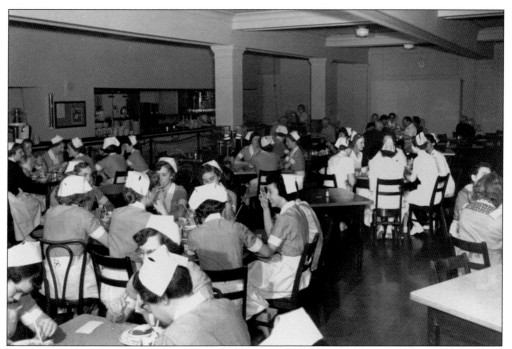

This is another mid-century view of the cafeteria. Close inspection reveals a fair number of nurses enjoying a cigarette after their meal, before the advent of nonsmoking rules in health care facilities.

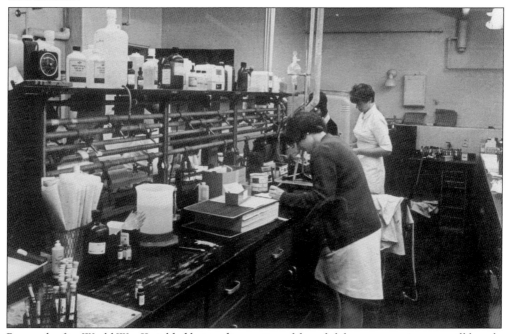

Research after World War II yielded better diagnostics, although laboratory testing was still largely manual prior to the arrival of automated processing equipment. Laboratory medicine facilities were located on the ground floor of the Chapin Wing prior to relocation in the Centennial (now Daly) Building after 1986.

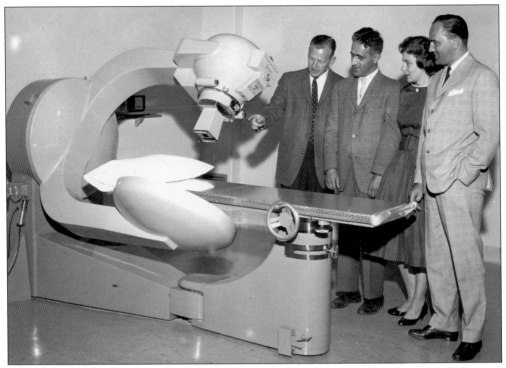

In 1960, a new Cobalt unit became available for cancer therapy. Examining the apparatus are, from left to right, Dr. Robert Grugan, Dr. Sante Caldarola, Mrs. Bozigian, and Dr. Haig Bozigian.

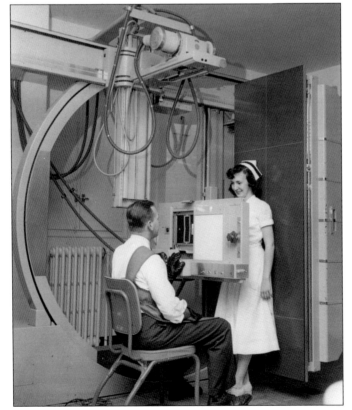

This mid-century photograph shows a fluoroscopy apparatus. The radiologist is wearing a lead apron and gloves to protect against occupational exposure to radiation. Radiology was originally located next to pathology on the ground floor of Springfield Main, just down the hall from the emergency area and the outpatient department in the Wright Wing.

Theodore Miner, MD, (left) and Kathleen Smith, RN, (right) are pictured during a disaster drill conducted in October 1961. The other man is unidentified. Dr. Miner was the director of the emergency room for many years.

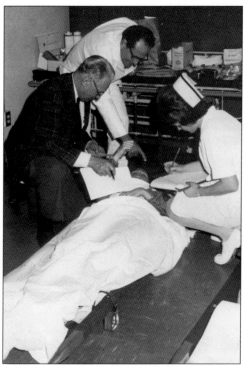

In January 1961, the West 1 Unit at Wesson Memorial Hospital was the first critical care unit to open in western Massachusetts. Springfield Hospital followed with its ICU on Main 5 later that year. Originally, the ICU accepted all surgical and medical patients, including cardiac emergencies. It was not until 1969 that dedicated coronary care units were established. Demonstrating a Bennett PR-1 respirator are, from left to right, Dorothea Tryon, RN; Jeannette O'Howe, RN; and Mary Mugnier, RN. These pneumatically powered units were a mainstay of artificial ventilation through the 1960s and 1970s.

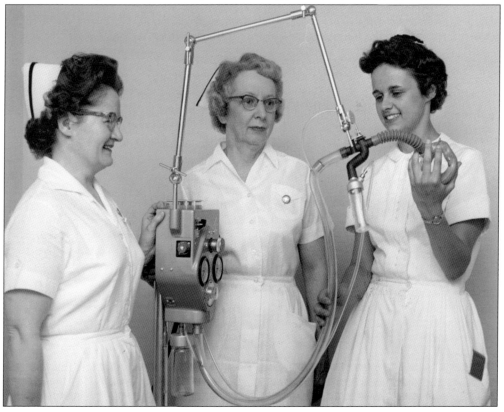

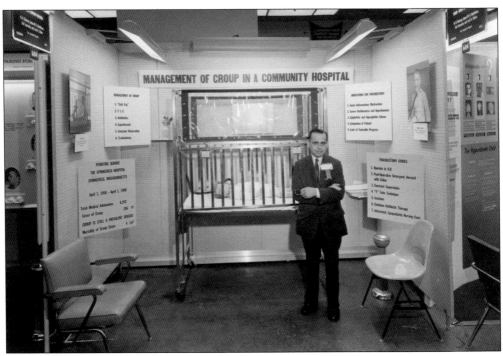

Despite having residency programs, Springfield Hospital did not consider itself an academic medical center. In 1961, Dr. H.H. Shuman presented "Management of Croup in a Community Hospital" at the American Medical Association meeting in New York City, presaging later growth in academic endeavors. Dr. Shuman later became the first director of the Neonatal Intensive Care Unit, the state-designated transfer nursery for critically ill newborns in western Massachusetts.

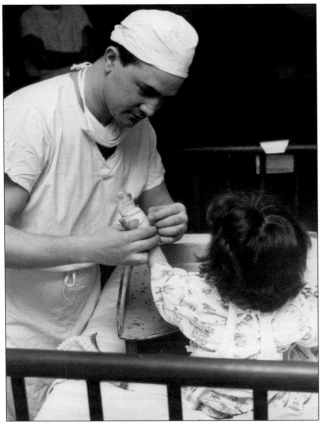

Dr. Sante Caldarola tends to a pediatric patient in 1955.

Laundry services occupied a separate building connected to the main complex by tunnels. This 1955 photograph shows two employees unloading extractor baskets in the linen processing area.

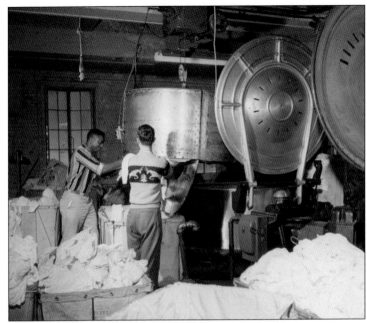

An employee is feeding washed linens into a dampening tumbler, after which it would pass to the spreader and flatwork ironer. The sign on the tumbler in this 1955 photograph states that, in 1954, Springfield Hospital processed more than one million pounds of laundry, including washing and ironing 41,276 starched uniforms.

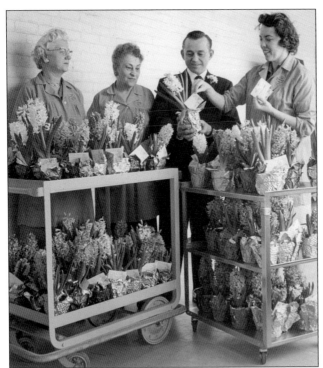

Flowers are always popular, but especially so at Easter. Pictured in 1961 are, from left to right, Mrs. Oliver J. Menard, Mrs. H. Hayes Landon, George Lewenchord of Allied Florists of Western Massachusetts, and Mrs. Gerald Pepin.

Elizabeth J. Gordon is shown at the hospital's switchboard. In 1960, operators still used patch cords to physically connect incoming trunk lines to individual phones. The box to the right is the overhead paging system.

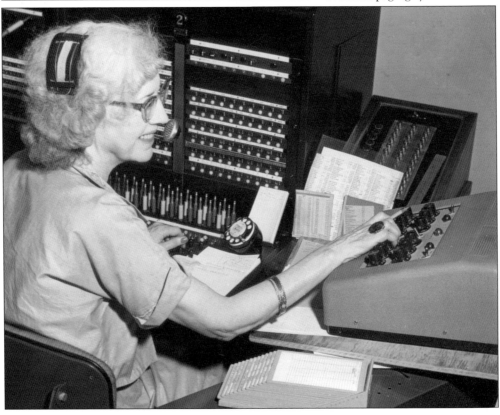

Seven

FROM HOSPITAL TO MEDICAL CENTER

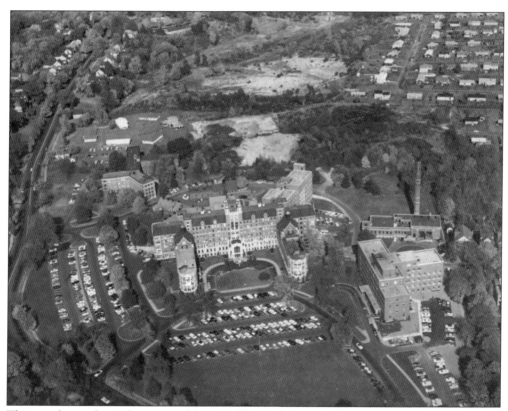

This aerial view shows the recent addition to Wesson Maternity (lower right), the completed East Wing attached to Springfield Main, and house officer quarters on the hill behind the nursing residences (upper left). A development of ranch houses (upper right) now occupies Cornwall Street, Lancashire Road, Croyden Terrace, and Mayfair Avenue at the time of this 1962 photograph.

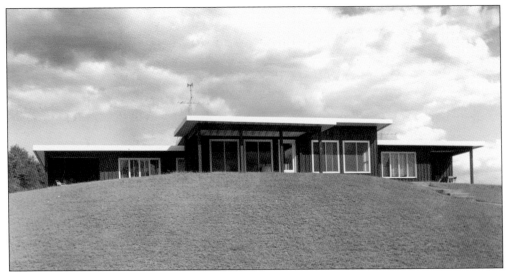

Following World War II, several residency training programs were instituted at Springfield Hospital. While interns were usually single and might live in the hospital for a year, residents often were starting families and needed better accommodations during their training, which could last up to five years. A number of small cottages and duplexes were constructed on the hill behind the hospital to serve as house officer quarters for doctors holding residency training positions. This view shows one of the more contemporary-looking buildings.

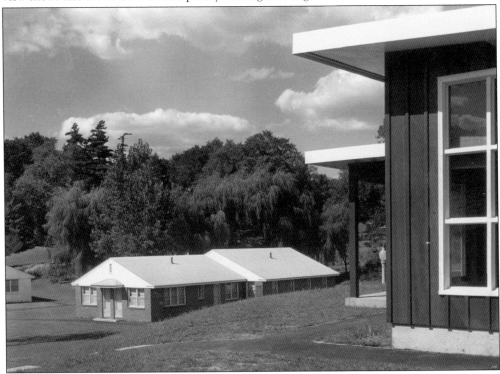

Here is another view of the house officer quarters, with the older cottages looking far more institutional than the more contemporary unit at the crest of the hill. On-campus housing for residents was a perquisite in an era when house officer salaries were meager.

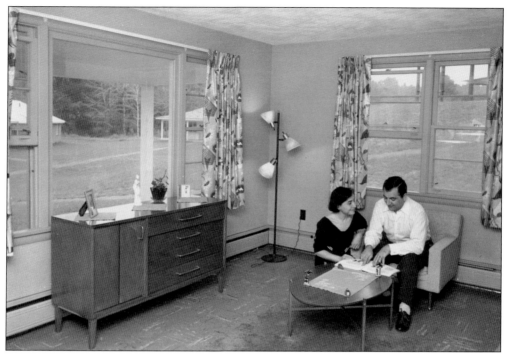

Dr. and Mrs. Sadat Pinar are shown in their house officer quarters. On-campus housing survived into the early 1980s. All quarters were then razed to accommodate the Centennial (now Daly) Building, as well as additional parking.

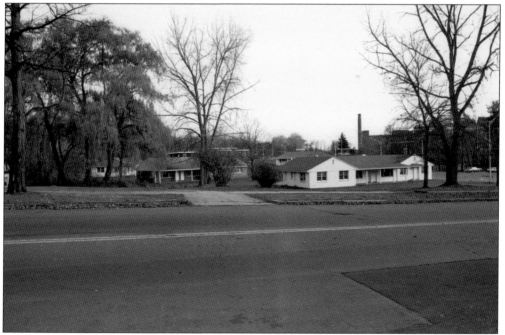

This view from Springfield Street shows the cottages in 1982, shortly before they were demolished. The smokestack and East Wing of the hospital are visible in the distance. Today, Medical Center Drive and the Daly Parking Garage occupy this space.

These are various pamphlets and clippings from the mid-1960s. The November 1966 issue of the *Intercom* includes the headline "The Dilemma Facing Hospitals Today: Problems of Rising Health Care Costs." The impressive entrance to Springfield Main became an iconic image on patient brochures and personnel handbooks.

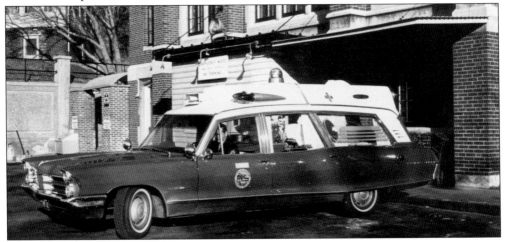

The emergency room occupied the northern end of the main building, where it was adjacent to the outpatient department on the ground floor. Seen in the late 1960s is an Agawam ambulance parked at the ambulance bay. This area later housed the medical records department. In the early 1990s, the connector to the new Wesson Women's Hospital building eliminated the driveway, and by then, the ambulance entrance and emergency department had moved first to the North Wing and then to the Centennial (now Daly) Building.

In 1968, Springfield Hospital became Springfield Hospital Medical Center, acknowledging its expanding role in teaching, research, and comprehensive specialty care. The sign on the switchboard dates this photograph to between 1968 and 1974. The indicators on the back wall were used to track the availability of physicians.

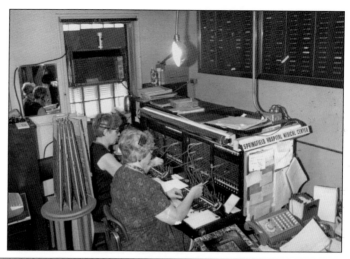

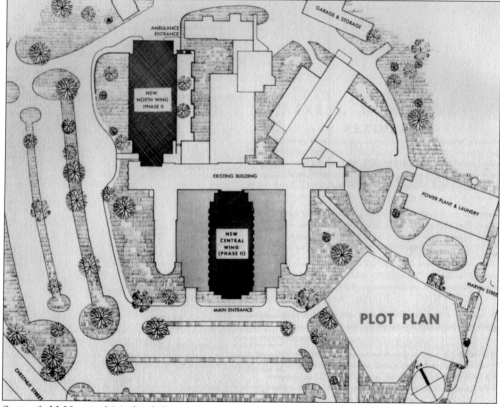

Springfield Hospital Medical Center's continued growth resulted in yet another bed shortage. This 1968 fundraising brochure proposed a new North Wing in Phase I and a new Central Wing in Phase II. In the North Wing, the ground floor would accommodate a physical medicine and rehabilitation department; the entire first floor would be dedicated to an expanded emergency department, with entry ports for two ambulances, a trauma operating room, and examination and treatment rooms; and the top three floors would boast 114 patient beds. With a completion date of August 1970, the first phase was estimated at $3.7 million. (Courtesy of Health Sciences Library, Baystate Medical Center.)

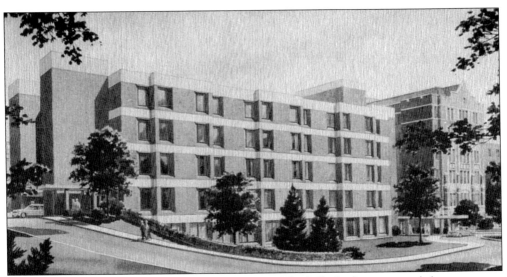

This is an architect's rendering of the North Wing. The hillside slope required the emergency department and its ambulance entrances to be on the first floor, while rehabilitation occupied the ground floor. (Courtesy of Health Sciences Library, Baystate Medical Center.)

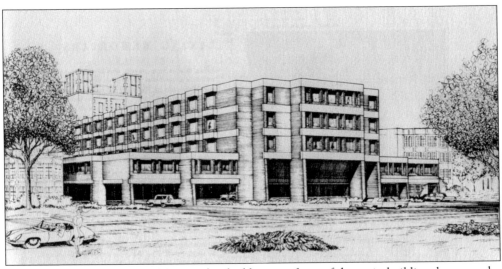

Phase II of the proposal called for a six-level addition in front of the main building, between the Wright and Chapin Wings. The basement, ground, and first floors would have completely filled the width of the space, with a narrower portion built up at the center to allow for windows in patient rooms on the top three floors. The ground floor would accommodate the main entrance, a coffee shop and gift shop, and areas for administration and personnel. The first floor would house 10 new operating rooms and two cystoscopy suites. The top three floors would each have 22 private rooms. Completion of both phases of the hospital would have brought the facility's bed count to 607, not including the 24-bed holding unit in the emergency department. The estimated cost of the project was $6.3 million. (Courtesy of Health Sciences Library, Baystate Medical Center.)

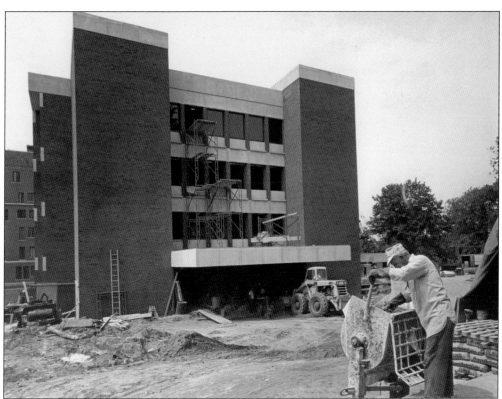

While the Central Wing fell victim to funding woes, Phase I of the project resulted in the North Wing, now known as the Wesson Wing. The canopy in this construction photograph would eventually shelter the ambulance entrance.

Dr. Alvin Keroack and an unidentified nurse tend to a trauma patient. Construction of the North Building expanded services from an emergency room to a full-fledged department occupying the entire first floor.

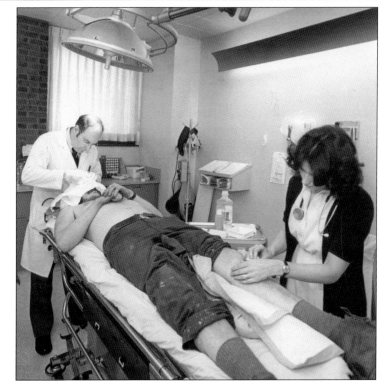

While intensive care units were built in 1961 at both Springfield and Wesson Memorial Hospitals, it was not until 1969 that a dedicated coronary care unit (CCU) was established. Initially, the CCU occupied the attic space on Wright 5. The fish-eye lens used for this photograph exaggerates the relatively small space under the eaves. The CCU later moved to spacious quarters on Centennial (now Daly) 5, before moving to the heart and vascular critical care unit in 2012. (Courtesy of BHM&C.)

In 1969, Drs. Jesse Hafer and Ralph Giannelly were the first to perform cardiac catheterizations at Springfield Hospital Medical Center. Both respected clinicians and beloved teachers, they later became founding members of the Baystate Medical Education and Research Foundation. Dr. Hafer is shown reviewing an EKG monitor tracing with two nurses and a resident in the original CCU. (Courtesy of BHM&C.)

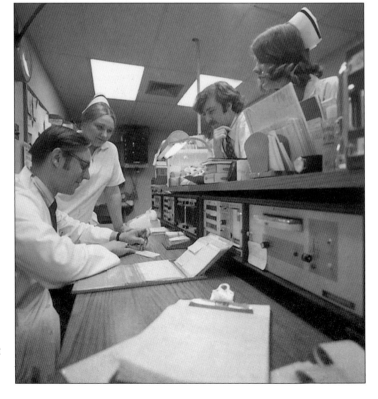

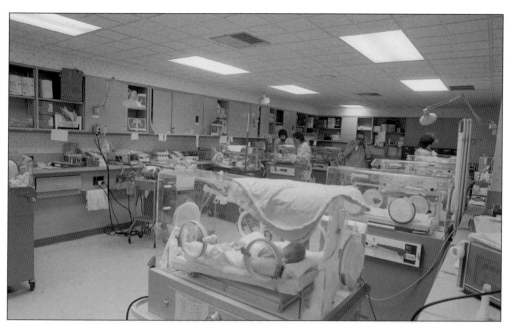

By the latter half of the 20th century, advances in neonatal care allowed more premature infants to survive with sophisticated ventilator and monitoring support. Baystate Medical Center opened the first neonatal intensive care unit (NICU) in western Massachusetts. The original NICU was located in the postwar Wesson Maternity Building, then later moved to the new Wesson. (Courtesy of BHM&C.)

The Springfield Hospital Women's Auxiliary sponsored the first Fall Follies in 1972, staging "Of Human Bandage." Proceeds from the first event supported purchase of cardiac monitors. This playbill dates from 1976. (Courtesy of BHM&C.)

The annual musical revues combined the efforts and talents of representatives from all walks of life in the hospital community. Here, employees rehearse in the living room of the Porter Building. (Courtesy of BHM&C.)

The Cargill Agency of New York professionally directed the Fall Follies productions, which featured elaborate costumes and a full orchestra. The events were staged at Springfield Symphony Hall. (Courtesy of BHM&C.)

Above is the chorus line from the 1976 Fall Follies. Sadly, this elaborate theatrical event did not continue after the mergers formed Baystate Medical Center. (Courtesy of BHM&C.)

Dr. Gregory Gallivan, a surgeon of Springfield Hospital, was also a talented opera singer, as seen in his Fall Follies performance at the Springfield Symphony Hall. (Courtesy of BHM&C.)

In 1968, Brightwood Riverview Health Center opened at 103 Division Street in Springfield's North End. This staff photograph was taken in the early 1990s, before the clinic moved to its present location at 380 Plainfield Street. (Courtesy of Audrey Guhn, MD, Baystate Brightwood Health Center/Centro de Salud.)

On May 14, 1982, Brightwood staffers Carmen Morales (left) and Carmen Lopez accept a plaque from the Spanish American Union honoring Brightwood Riverview Health Center for meritorious service to the Hispanic community of Springfield. (Courtesy of BHM&C.)

Eight

MEDICAL CENTER OF WESTERN MASSACHUSETTS/ BAYSTATE MEDICAL CENTER

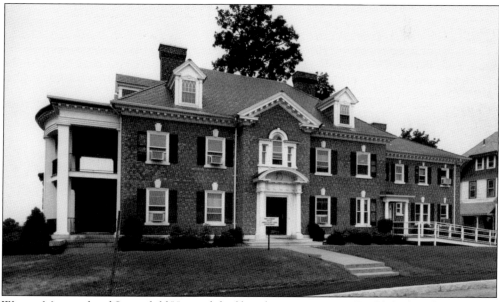

Wesson Memorial and Springfield Hospitals had long been competitors. Established as a homeopathic institution, Wesson Memorial stressed routine medical and surgical care, patient contact over research, and financial stability, while Springfield Hospital boasted more specialists and advanced care, large training programs, and periodic financial crises. On October 1, 1974, Springfield Hospital Medical Center merged with Wesson Women's Hospital to create the 672-bed Medical Center of Western Massachusetts (MCWM). Meanwhile, Wesson Memorial had begun to position itself as the region's heart, cancer, and stroke center. In 1975, both Wesson Memorial and MCWM proposed the acquisition of expensive linear accelerators to generate high-energy particles for radiation therapy, the cost of which alarmed the community and the trustees. Taking matters into their own hands, trustees of Wesson Memorial and MCWM engineered a 1976 merger to create the 1,036-bed Baystate Medical Center. Pictured above is a former mansion at 12 Ingraham Terrace, near Wesson Memorial Hospital, that served as corporate headquarters.

Harry C.F. Gifford (right) arrived at Springfield Hospital in June 1961 and became the first president of the newly created Baystate Medical Center. He is shown here presenting a commendation to senior physician Dr. Walter Nero in 1986.

Donald Wetherbee, vice president of the Wesson Memorial Unit, is pictured at his retirement party in 1986. He served as the leader of the transition for physicians and staff during the merger of Wesson Memorial with Springfield Hospital. Also pictured are, from left to right, Wesson Memorial director Sara McCracken, registered nurse Bobbie Fountain of the Wesson Memorial ER, and assistant Linda Baillargeon.

Thomas G. Carr was a founder of Bay Path College who served on the board of trustees of Baystate Medical Center and its predecessors for more than 50 years. As chairman of the finance committee, he was instrumental in the 1976 merger. Having been confined to a wheelchair since a 1952 car accident, he brought the perspective of a patient to his role as a hospital trustee. The hospital dedicated the boardroom in his honor in 1990. (Photograph by Todd Lajoie; courtesy of BHM&C.)

In February 1979, Baystate Medical Center's medical staff leadership included, from left to right, (seated) vice president Bill Janes and president Max Cloud; (standing) secretary Eckart Sachsse and treasurer Phil Stoddard. (Courtesy of BHM&C.)

107

Michael J. Daly was president and chief executive officer of Baystate Health from 1980 to 2004. Under his visionary leadership, Baystate grew from a single academic medical center to the first multihospital system in Massachusetts. It became an integrated delivery system, encompassing outpatient practices, the Visiting Nurse Association, regional laboratory services, and the Health New England insurance company. (Courtesy of BHM&C.)

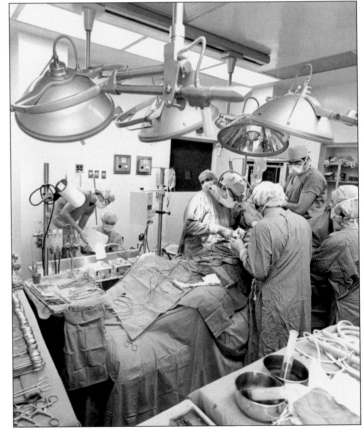

With cooperation replacing competition, Baystate was able to secure funding to become a cardiac center. On February 2, 1978, Dr. Richard Engelman (wearing headlamp and surgical loupes) and Dr. John Rousou (third from right) performed the first open-heart surgical procedure in western Massachusetts at Baystate Medical Center. The cardiac surgical team later pioneered "fast-track" accelerated recovery after coronary bypass surgery.

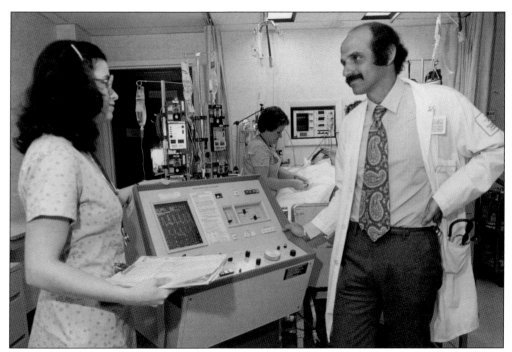

The increased financial strength of the merged hospitals facilitated program development, the acquisition of new equipment, and an influx of new specialists. Cardiologist Mark Schweiger is shown in the coronary care unit discussing intra-aortic balloon pump settings with an unidentified CCU nurse. (Courtesy of BHM&C.)

Baystate Medical Center established a multidisciplinary critical care group in 1979. The concept of full-time intensivists (critical care specialists) in a closed ICU setting predated the recommendations of the Leapfrog Group (patient safety organization launched in 2000) for intensive care some 20 years later. This view of the ICU, then on Springfield 5, features nurses Lauren Guilbault and Kevin Young tending to a patient. (Courtesy of BHM&C.)

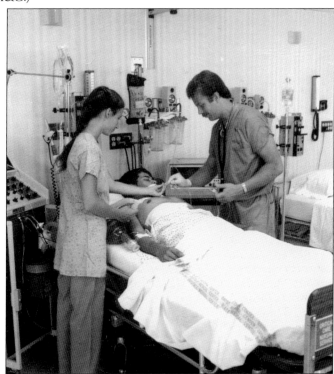

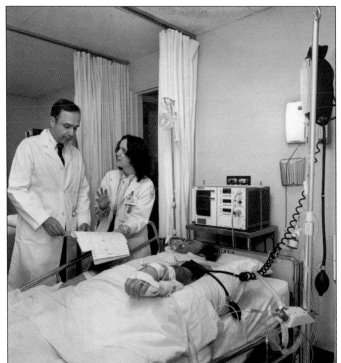

Medical and surgical patients shared a single multidisciplinary ICU between 1961 and 2012. Here, Dr. Paul Friedmann, chairman of surgery from 1971 to 1998, discusses a patient's care with surgical resident Bridgid Glackin in February 1981. (Courtesy of BHM&C.)

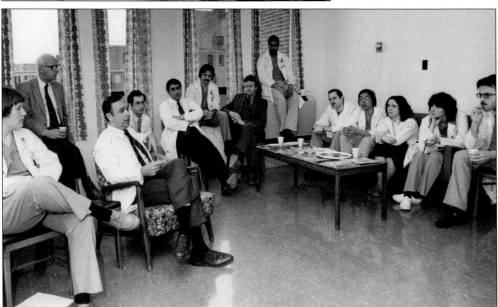

In 1948, Springfield Hospital established a surgical training program, commissioned by the Accreditation Council for Graduate Medical Education in 1949. Chairman's rounds, which include residents, medical students, and faculty, are important for debriefing and instruction. Pictured in the solarium on Chapin 3 in 1981 are, from left to right, Dr. Kathy Porter, Dr. Hartshorn, Dr. Paul Friedmann, Dr. Wally Salwen, Dr. Ferdauz Canteenwalla, Dr. Ken DeVellis, Dr. Nicholas Coe, Dr. Mike Taylor, Dr. Kim Krach, Dr. Richard Yee, Dr. Bridgid Glackin, and two unidentified medical students. (Courtesy of BHM&C.)

Dr. Martin Broder (left), chairman of medicine from 1982 to 2002, is shown at his welcoming reception talking to chief medical resident Roland Alexander. Dr. Broder was instrumental in developing the medicine residency program and establishing the High Street Health Center as the primary ambulatory training site for medical residents. (Courtesy of BHM&C.)

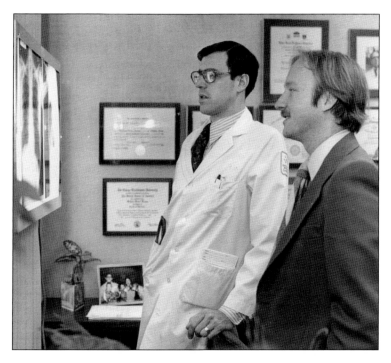

In 1986, the Baystate Medical Education and Research Foundation (BMERF) was established to employ full-time teaching and research faculty. Dr. Richard Brown (left), shown here with internist Dr. David Clinton, was one of the inaugural members and the long-standing chief of the infectious disease division. (Courtesy of BHM&C.)

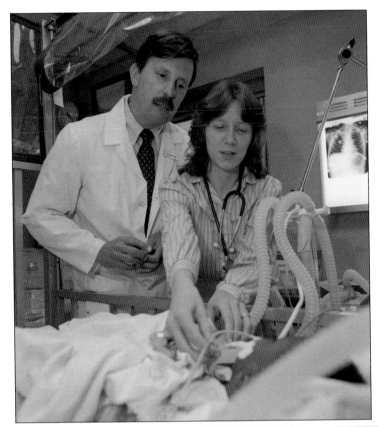

Dr. Edward Reiter was chair of pediatrics at Baystate from 1981 to 2008. He is shown here in 1985 working with resident physician Patricia Edwards in the pediatric ICU. (Courtesy of BHM&C.)

Springfield Hospital had already established residency programs in medicine, surgery, anesthesiology, pathology, radiology, pediatrics, and obstetrics/gynecology. After the merger forming Baystate, a number of subspecialty fellowships were established, followed by additional residencies in emergency medicine (1992) and psychiatry (2008) to complete the specialty training options. Interns Robert Ficalora (left) and Robert Tenofsky-Ealy are learning intubation skills in this 1982 photograph. Dr. Ficalora later became the residency program director of internal medicine. (Courtesy of BHM&C.)

Following the merger, inpatient care gradually was consolidated to the Chestnut Street campus. The cafeteria and emergency room areas of the former Wesson Memorial at 140 High Street were remodeled to accommodate outpatient adult and pediatric clinics and ancillary services. Serving over 9,000 adult patients, High Street Health Center is now the primary ambulatory training site for internal medicine and pediatric residents. (Photograph by Todd Lajoie; courtesy of BHM&C.)

Laurence E. Lundy, MD, was appointed as chief of obstetrics and gynecology after the 1974 merger. Instrumental in post-merger physician relations, Dr. Lundy took the obstetrics/gynecology residency to world-class status. After his retirement in 1996, the Lundy Board Room on the ground floor of the new Wesson Building was named in his honor. (Courtesy of BHM&C.)

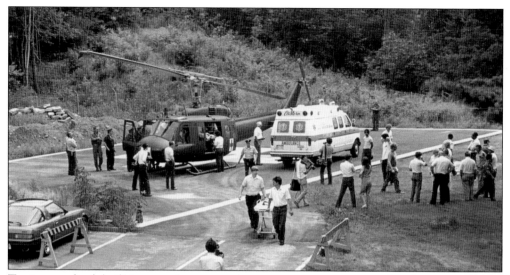

Tertiary medical facilities must be prepared to accept emergency transfers from surrounding hospitals. This training exercise, held on August 11, 1982, shows Baystate's helicopter landing pad on the hill above the Centennial Building. Ambulances were required to transport patients between the helicopter and the hospital, only a few hundred yards away. This inconvenience was remedied with construction of a new helipad, which opened atop Baystate Medical Center in 2012. (Courtesy of BHM&C.)

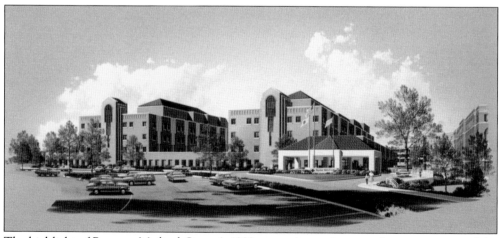

The highlight of Baystate Medical Center's 1983 expansion project was the construction of the Centennial Building, shown here in an architect's rendering. (Courtesy of BHM&C.)

Local dignitaries partake of a massive cake in the shape of the expanded Baystate Medical Center at the ground-breaking ceremonies for the Centennial Building on October 21, 1983. (Courtesy of BHM&C.)

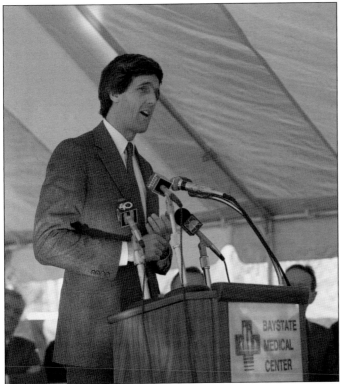

John Kerry was lieutenant governor of Massachusetts when he spoke at the 1983 ground-breaking ceremonies for the Centennial Building. He subsequently won election to the US Senate in 1984, ran unsuccessfully for president in 2004, and was appointed by Pres. Barack Obama to succeed Hillary Rodham Clinton as secretary of state in 2013. (Courtesy of BHM&C.)

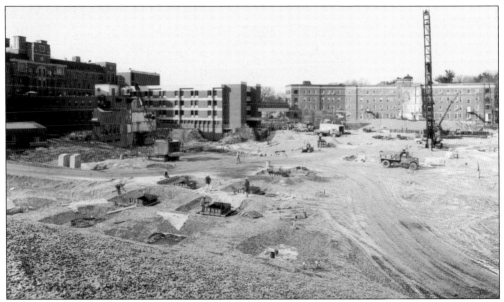

The grounds have been cleared and footings are being poured for construction of the Centennial Building in this view from December 1983. The building was later renamed in honor of Michael Daly, chief executive officer of Baystate from 1980 to 2004. (Courtesy of BHM&C.)

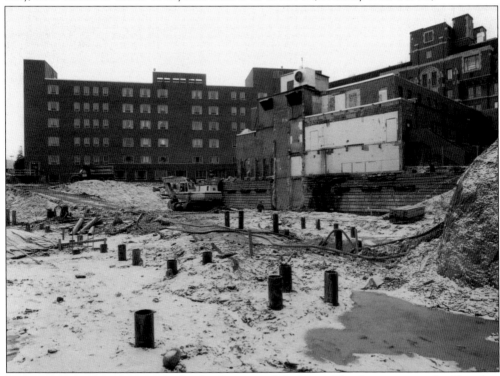

Here, construction is in progress for the Centennial Building. The former service building has been stripped back to the rear wall of the original 1889 hospital. The East Building is seen at left, and one of the large operating room windows on the sixth floor of Springfield Main is visible at right. (Courtesy of BHM&C.)

A six-floor walkway (tall steelwork at left) and an expanded kitchen/cafeteria building (low steelwork in foreground) encapsulated the original three-story hospital (center), as demonstrated in this aerial view. The tall steelwork at right would connect the future Centennial Building (foundation in the foreground) to the West Wing (now the Wesson Building), also to the right. (Courtesy of BHM&C.)

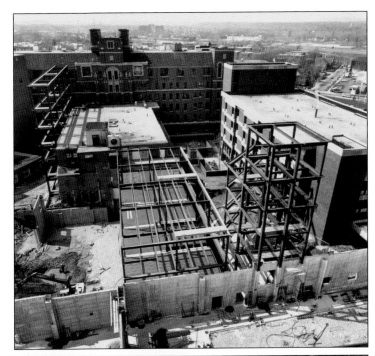

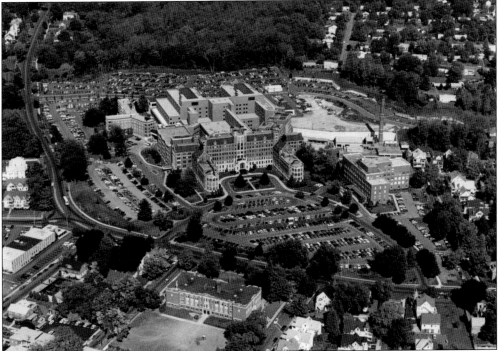

This aerial view shows the completed Centennial (now Daly) Building in close proximity to the Porter-Harris Building. The clearing to the right of Springfield Main would accommodate the future Medical Office Building, and the new Wesson Wing would soon replace the ambulance entrance and parking lot to the left. The T-shaped Wesson Maternity (just below the powerhouse) eventually would become the Chestnut Surgical Center. (Courtesy of BHM&C.)

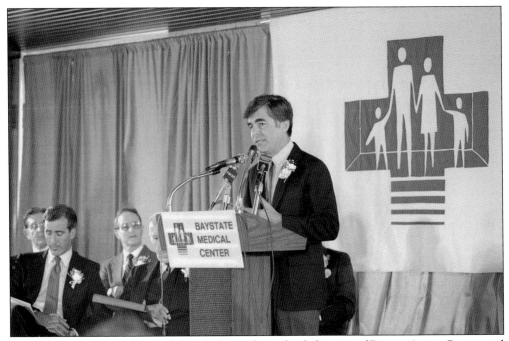

Massachusetts governor Michael S. Dukakis spoke at the dedication of Baystate's new Centennial Building in May 1986. Dukakis served as governor from 1975 to 1979 and again from 1983 to 1991. He lost his presidential bid to George H.W. Bush in 1988. (Courtesy of BHM&C.)

In 1986, construction workers pose in front of the newly completed Centennial Building, which totaled $67 million. The hospital's main entrance would shift to this location on the third floor because of the sloped site. The top three floors accommodate patient rooms, including new adult and pediatric intensive care units. Below grade are new operating rooms and laboratory facilities, replacing cramped space in Springfield Main. (Courtesy of BHM&C.)

The first floor of the new Centennial Building provided ample space for laboratory medicine. In 1986, the hospital would accommodate 35,585 admissions and 238,760 patient days (aggregate number of patient hospitalization days) at an average length of stay of 6.5 days. (Courtesy of BHM&C.)

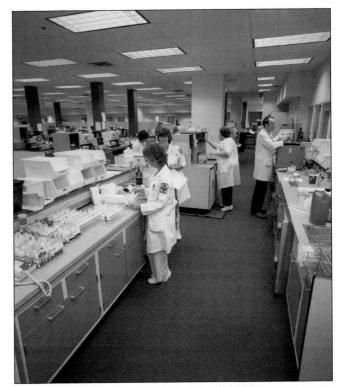

With the opening of the Centennial Building, most inpatient operations were moved to the new facilities, relieving the pressure on Springfield 6. In 1986, a total of 9,320 inpatient and 4,597 outpatient surgical cases were conducted. Below, cardiac surgery is being performed on September 3, 1986. (Courtesy of BHM&C.)

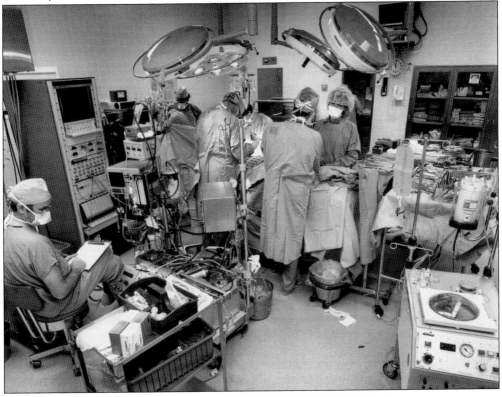

Ernie Caffee joined Springfield Hospital in 1971 and held several positions in food services before becoming a production cook. He recently celebrated 43 years with the organization.

The hospital kitchens originally occupied the basement of the 1889 building, which was renumbered as the first floor. With construction of the Centennial Wing, the original kitchen, shown here around 1980, was expanded. The employee cafeteria, one floor above, was also reconstructed and enlarged.

The fourth floor of the Centennial Building accommodated expanded pediatric services and a new pediatric intensive care unit (PICU). Baystate Department of Pediatrics was designated as a children's hospital in 1992. Bandy Bear became the symbol of the children's hospital, as well as a popular visitor to the pediatric wards. With 110 beds and 57 bassinets, Baystate Children's Hospital provides complete pediatric care, including the region's only pediatric intensive care and neonatal care units and the only dedicated pediatric emergency room.

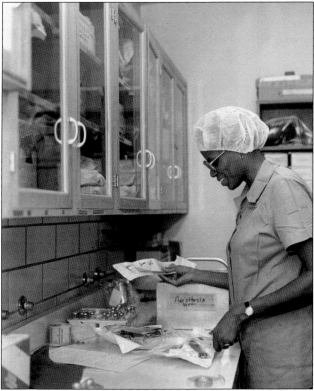

Valarie Johnson, RN, manager of anesthesia technicians, is shown in the Springfield 6 operating suite. Anesthesia technicians are responsible for preparing vital equipment, including the laryngoscopes used by anesthesiologists and nurse anesthetists.

Baystate was a pioneer in electronic medical records and introduced electronic physician order entry in 1991. At the time, state-of-the-art technology involved a light pen used to select orders on a monochrome monitor. (Courtesy of BHM&C.)

The steps of the Porter Building made for a popular spot for annual house staff photographs. This 1989 image shows the teaching faculty and residents in the Department of Medicine. With the closure of the nursing school in 1999, the Porter-Harris Building housed nursing, quality administration, and faculty offices. The Hospital of the Future complex, including the Davis Family Heart & Vascular Center and the MassMutual Wing, currently occupies this site. (Courtesy of Richard Brown, MD.)

Nine

BAYSTATE IN THE 21ST CENTURY

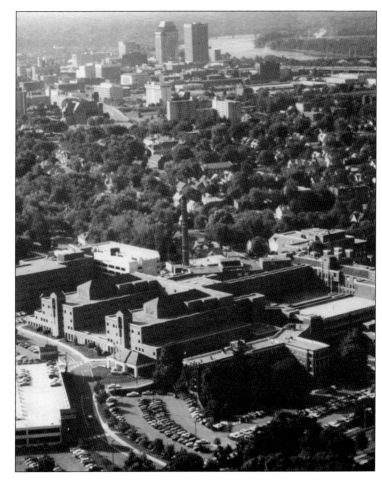

This aerial view from 1993 shows the Baystate Medical Center campus, featuring new parking garages and the Medical Office Building next to the Centennial Building. Downtown Springfield and the Connecticut River are visible at the top of the photograph. (Courtesy of BHM&C.)

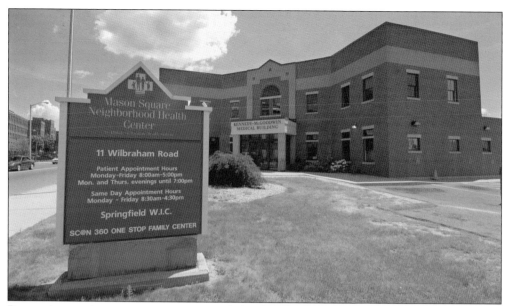

Baystate's commitment to its community includes three health centers: Brightwood Health Center, founded in 1968, is located on Plainfield Street in the North End. Mason Square Neighborhood Health Center, founded as the Women's Neighborhood Health Center in 1970, moved to 11 Wilbraham Road (pictured here) in 1996. The High Street Health Center opened on the site of the former Wesson Memorial Hospital in 1981. (Courtesy of BHM&C.)

During the late 1980s and 1990s, the Lucky Duck Race raised funds for the Children's Miracle Network at Baystate Children's Hospital. The event was held in conjunction with the World's Largest Pancake Breakfast in Springfield, which took place each May. Typically, some 20,000 sponsored and numbered rubber ducks were "dumped" from the Memorial Bridge into the Connecticut River to start the race. Baystate volunteers designed, built, and maintained the giant yellow Lucky Duck float, which also made a regular appearance in the Holyoke St. Patrick's Day Parade. This photograph was taken on May 14, 1994. (Courtesy of BHM&C.)

In 1998, the Brightwood Neighborhood Health Center/Centro de Salud moved to the newly built Benjamin Ramos Building at 380 Plainfield Street in the North End. Benjamin Ramos is shown here at the building's dedication. (Courtesy of BHM&C.)

Baystate Medical Center and the University of Massachusetts Amherst had collaborated on biomedical research since the 1980s. Building on this success, the two institutions formed the Pioneer Valley Life Sciences Institute (PVLSI) in 2002 to provide state-of-the-art research facilities close to the increasingly crowded Baystate campus. In this photograph, PVLSI director Paul Friedmann, MD, and Massachusetts senator Edward M. Kennedy speak at the facility's dedication. PVLSI is located in a repurposed industrial building on North Main Street. (Courtesy of BHM&C.)

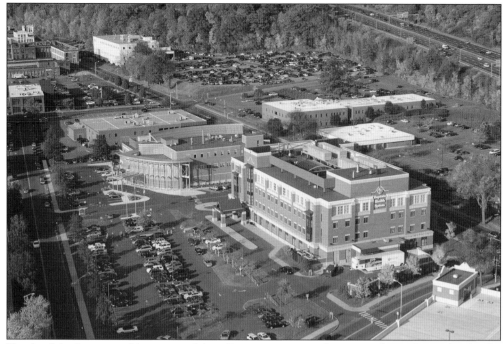

North of the Interstate 91 overpass, Main Street was once a thriving industrial area, but by the 1990s, it was largely composed of abandoned factories and vacant lots. Baystate Medical Center initially purchased North End properties to expand employee parking. Over time, North Main Street has developed into a center for outpatient medical care. The Tolosky Center at 3300 Main Street, the D'Amour Cancer Center at 3350 Main, and Employee Health at 3400 Main occupy the block between Birnie Avenue on the west and Main Street on the east, bordered by Wason Avenue on the north and Walter Street and the parking garage on the south. The Pioneer Valley Life Sciences Institute occupies the large white building at the top of this 2004 aerial photograph. (Courtesy of BHM&C.)

Mark Tolosky (left) joined Baystate in 1992 as executive vice president of Baystate Health and chief executive officer of Baystate Medical Center. In 2004, he succeeded Michael Daly as president and chief executive officer of Baystate Health. Under his leadership, Baystate was named one of the nation's top 15 integrated health systems. He is pictured here with Mark Keroack, MD, who became president and chief executive officer of Baystate Health in 2014. (Courtesy of BHM&C.)

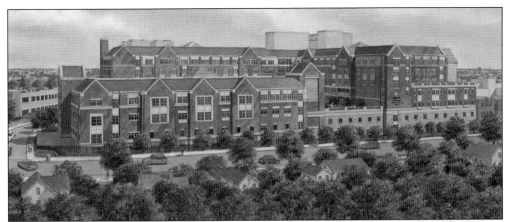

In 2007, Baystate Medical Center began planning for a visionary new facility to meet community needs. Hundreds of people—from patients to care providers to the community at large—shared ideas and experiences to help design the 641,000-square-foot, $300 million facility, which includes a heart and vascular center and new patient care units with all private rooms. On the first floor, a new emergency department more than tripled the available space for emergent care. Officially dedicated on February 28, 2012, this new section of Baystate Medical Center was first occupied in March of that year. The complex consists of three low-rise towers above a massive base that houses the Davis Family Heart & Vascular Center. (Courtesy of BHM&C.)

Baystate threw a "red tie" gala (variant of black tie often used for charity causes) to inaugurate the Baystate Medical Center expansion on February 26, 2012. Community members, donors, and physicians were invited to tour the facility ahead of its March opening. The physician band Too Many Beepers provided entertainment to a crowd of 500 in the shell space for the future pediatric wing. From left to right are John Egelhofer, Stephen Lieberman, Thomas Hayowyk, Thomas Higgins, and David Desilets. The staff and providers of Baystate Medical Center continue their charitable mission of improving the health of the community every day with quality and compassion. (Courtesy of BHM&C.)

DISCOVER THOUSANDS OF LOCAL HISTORY BOOKS FEATURING MILLIONS OF VINTAGE IMAGES

Arcadia Publishing, the leading local history publisher in the United States, is committed to making history accessible and meaningful through publishing books that celebrate and preserve the heritage of America's people and places.

Find more books like this at
www.arcadiapublishing.com

Search for your hometown history, your old stomping grounds, and even your favorite sports team.

Consistent with our mission to preserve history on a local level, this book was printed in South Carolina on American-made paper and manufactured entirely in the United States. Products carrying the accredited Forest Stewardship Council (FSC) label are printed on 100 percent FSC-certified paper.

MADE IN THE **USA**